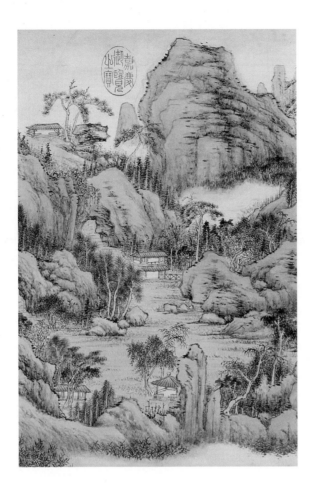

BRILLIANT *Strokes*

Chinese Paintings from the Mactaggart Art Collection

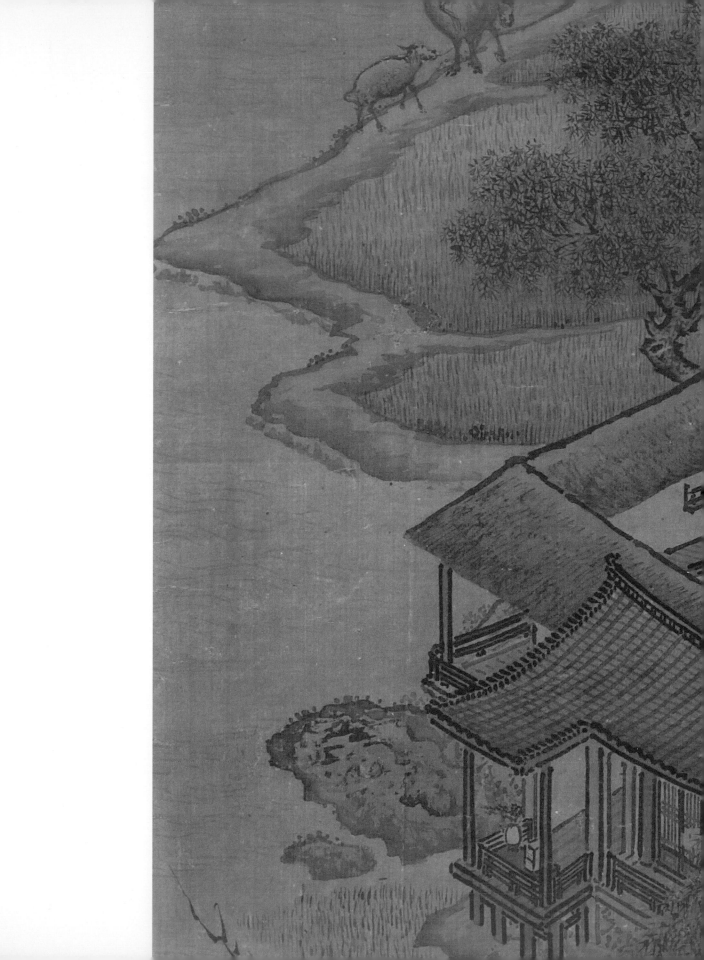

BRILLIANT *Strokes*

Chinese Paintings from the Mactaggart Art Collection

KA BO TSANG

Gutteridge
BOOKS
An Imprint of The University of Alberta Press

museums
UNIVERSITY OF ALBERTA

University of Alberta Museums

Ring House 1

Edmonton, AB

Canada T6G 2E1

and

University of Alberta Press

Ring House 2

Edmonton, AB

Canada T6G 2E1

Book design: Alan Brownoff

Text editor: Margaret Barry

Photography: Creative Services, University of Alberta

Scans: Dave Vasak

Printed in Canada by McCallum Printing Group Inc., Edmonton, Alberta.

LIBRARY AND ARCHIVES CANADA CATALOGUING IN PUBLICATION

Mactaggart Art Collection

 Brilliant strokes : Chinese paintings from the Mactaggart Art
Collection / Ka Bo Tsang.

Co-published by University of Alberta Museums.
Includes bibliographical references and index.
ISBN 978–1–55195–216–1

 1. Painting, Chinese—Ming Qing dynasties, 1368–1912—
Exhibitions. 2. Painting, Chinese—20th century Exhibitions.
3. Mactaggart, Sandy—Art collections—Exhibitions. 4. Mactaggart,
Cécile E., 1939– —Art collections—Exhibitions. 5. University of
Alberta. University of Alberta Museums—Exhibitions. I. Tsang, Ka Bo
II. University of Alberta. University of Alberta Museums. III. Title.

ND1040.M23 2008 759.951'074712334 C2008–903423–6

The University of Alberta Press gratefully acknowledges the support
received for its publishing program from The Canada Council for the Arts.
It also gratefully acknowledges the financial support of the Government
of Canada through the Book Publishing Industry Development Program
(BPIDP) and from the Alberta Foundation for the Arts for our publishing
activities.

Published in conjunction with the University of Alberta Museums'
exhibition *Brilliant Strokes: Chinese Paintings from the Mactaggart Art Collection*
in Gallery A at the TELUS Centre for Professional Development on
the University of Alberta campus, Edmonton, Canada, September 18,
2008–January 24, 2009.

Entire scrolls can be viewed online at:
www.museums.ualberta.ca/mactaggart

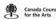

Half titlepage image: Detail of Complete View of the Lion Grove.
Titlepage image: Detail of Summer Retreat at Lakeside Village.

Contents

Foreword

BRILLIANT STROKES is the second phase of the University of Alberta Museums' exciting vision to build a program of research-based discovery learning activities that ensure access to the Mactaggart Art Collection for people of all ages and interests, and from our local and world-wide communities. It is a collaborative project that includes an exhibition, an interdisciplinary outreach program and an enduring record in the form of this descriptive catalogue.

The Mactaggart Art Collection is part of the larger consortium of the University of Alberta Museums — a network of 35 museums and collections in diverse disciplines that are linked through a common goal of object-based learning. The Mactaggart Art Collection includes more than 700 paintings, textiles, costumes and related artifacts dating from the Song dynasty (960–1279) to the present. Notable among these are the Southern Inspection Tour scroll from 1764–1770 and the *Huangchao liqi tushi* (A Collection of Drawings of Ceremonial Paraphernalia of the Qing Dynasty) both of which are featured in *Brilliant Strokes*. The university's benefactors, Sandy and Cécile Mactaggart began collecting and documenting Asian art in the early 1960s and over the next 40 years put together one of the world's finest privately-held collections. In 2005, their generous donation of this remarkable collection placed the University of Alberta among few institutions in North America where rare artifacts such as these can be viewed, studied and appreciated first-hand.

A collection of this importance has brought us the good fortune of meeting scholars and experts from around the world. One of our first encounters was with Dr. Ka Bo Tsang, Curator of Chinese Painting at the Royal Ontario Museum and from this was born the idea of *Brilliant Strokes*. The exhibition and its companion catalogue introduce us to a careful selection of seventeen of the most significant paintings in the collection which also demonstrate the diversity of styles, techniques, and media represented in the Mactaggart Art Collection. Through the development of this exhibition, Ka Bo's guidance, insights and camaraderie have been invaluable. Her research is impeccable and is the beginning to a great scholarly body of knowledge related to the Mactaggart Art Collection.

Each painting selected for *Brilliant Strokes* helps us to understand how to view, read and interpret this amazing collection. The centuries-old study of Chinese paintings tells of the importance of the artists and literati, who discussed paintings at social occasions, adding poetry, comments and inscriptions in the form of colophons and seals. Through this information, scholars are able to learn more about the artist, the artwork, past owners and admirers, and the layers of interpretation created over time. Ka Bo's detailed descriptions and translations are in a sense her colophons, providing interpretations and insights from a twenty-first century admirer.

As the new owners of these important works of art held in public trust, the University of Alberta will ensure that gatherings of scholars continue to take place so that new research, interpretations, and comments can add to the body of knowledge on Chinese painting. *Brilliant Strokes* is our modern-day version of these gatherings and provides an excellent introduction to the paintings in the Mactaggart Art Collection and a framework for others to build upon.

Janine Andrews
Executive Director
University of Alberta Museums

Introduction

BRILLIANT STROKES: *Chinese Paintings from the Mactaggart Art Collection* is the second in a series of publications produced by the University of Alberta Museums to highlight the acquisition of this new collection. Under contract to the University of Alberta Museums, I have researched seventeen Chinese paintings from the Mactaggart Art Collection that have been selected for display in the University of Alberta Museums Gallery A, an intimate space designed to foster discovery learning.

Notwithstanding the small number, these paintings are representative of the breadth and high quality of the collection. The paintings span a period of five hundred years—from the fifteenth century to the twentieth century. Their formats encompass the standard hanging scroll, handscroll, album, and folio, as well as a rather unusual large-scale wall-mounted painting. In medium of execution, they include monochrome and polychrome works on paper and silk, as well as engravings. In subject matter, they comprise landscape, figural theme, costume, animals, plants, and important historical events. The painting techniques illustrate a great variety of methods, including *baimiao* (plain drawing), *shuanggou* (double outlines), *gongbi* (meticulous drawing), *xieyi* (jotting down ideas), and *mogu* (boneless, such as images rendered in washes with no contours). Painting styles exemplify the distinctive manners favoured by artists of different allegiances—as examples, the deliberately unrefined flavour embraced by the literati, the antique spirit esteemed by followers of the orthodox school, the highly polished and decorative look preferred by professional and court painters, and the spontaneous expression cherished by free-spirited practitioners.

The status of the painters also reflects an interesting spectrum of the people who produced these selected pieces. There are scholars, officials, professional painters, foreign missionary painters, court painters, and even a courtesan. The places where they lived and worked include: Beijing, Taiyuan, and Xi'an in northern China; Nanjing, Suzhou, Yangzhou, and Hangzhou in the east; and Guangzhou and Hong Kong in the south. The reasons for their creations range from personal enjoyment to gift-giving; and from responding to a patron's request to undertaking a royal commission.

In addition to appreciating the artistic skills of these painters, we may learn something about their aspirations, emotions, and inner visions through these works. We may also learn about the diverse aspects of life in the China of bygone days. To this end, I have provided concise background information about the artists and their paintings. Due to the complexity of certain subjects, more research is needed for some of these included works.

This catalogue signifies initial research conducted on a small fraction of the Chinese painting component in the Mactaggart Art Collection. It is a tribute to the University

of Alberta, which had the foresight to open its door to this world of Chinese art. In its new home, the Mactaggart Art Collection—already known as one of the world's great private collections—will increase understanding of the art and culture of China. Undoubtedly, this very important collection will become better known in Canada and around the world.

Dr. Ka Bo Tsang
Curator of Chinese Painting
Royal Ontario Museum

Acknowledgements

I HAD THE GOOD FORTUNE of seeing the Chinese painting component of the Mactaggart Art Collection twice, in the autumn of 2003 and 2005 respectively. I was invited the first time to assist the staff at the University of Alberta Museums in documenting the paintings after they had been transferred from the Mactaggart's home to the university. The condition of each piece was examined and measurements were taken. I was impressed by everyone's suppressed excitement each time a painting was taken out of its storage cabinet, fitted box, or fabric wrapper. I was equally touched by the consideration the staff displayed when they unrolled a scroll or turned a leaf in an album. I saw reverence in their eyes.

My first visit lasted four days. I managed to see the better part of the collection, but left feeling that although I was very privileged to see such a treasure trove, there had not been sufficient time for me to really enjoy looking at the paintings that I particularly liked. It was therefore very gratifying to be able to visit the collection a second time. This time, I had the even more enjoyable and welcome task of making a selection for an exhibition, to be mounted first at the University of Alberta and then at the Royal Ontario Museum. These were the small beginnings of the genesis of *Brilliant Strokes: Chinese Paintings from the Mactaggart Art Collection*.

On both visits to Edmonton I was invited to stay at the beautiful home of Sandy and Cécile Mactaggart. My warm and gracious hosts made every effort to make me feel comfortable. Cécile's witty remarks and vivacious laughter were disarming, making me feel truly welcome. I am most grateful to them for their kindness and interest in the exhibition and its accompanying catalogue. Also, on both occasions I was warmly received by Janine Andrews, Executive Director, University of Alberta Museums; Jim Corrigan, Curator, University of Alberta Art Collection; Frannie Blondheim, Associate Director, University of Alberta Museums; and Pauline Rennick, Collections Management Manager. During the second visit they made sure that I saw what I wanted to see and provided me with all the information I needed. Frannie and Pauline even took the trouble to give me a tour of campus in the vicinity of Ring House 1, their office building, so that I could go away with some idea of the pace of growth of this thriving university. After my departure, Jim arranged for a professional photographer to take high-resolution digital images of the whole painting collection. He later made sure that images of the selected works were available to me for research. Janine was instrumental in implementing the ideas of a Chinese painting exhibition and a catalogue. It was through her that I met Linda D. Cameron, Director of the University of Alberta Press. I am much indebted to both of them for their enthusiastic support of the project. I also sincerely hope that there will be more joint ventures between the University of Alberta and the Royal Ontario Museum in the future.

At the ROM I wish to thank my colleague Klaas Ruitenbeek for introducing me to the Mactaggarts; Christine Lockett, Director, Exhibit Planning and Community Programs, and Mary Montgomery, Exhibit Planner, for taking care of the administrative aspects of a loan exhibition; and Jack Howard, Librarian of the H.H. Mu Far Eastern Library, and Kang-mei Wang, Librarian Technician, for their prompt and helpful response whenever I cried for bibliographical assistance during the short period available for the preparation of this catalogue. Jack deserves special mention here. Just as he has done over many years, he has again generously given me moral and tangible support this time around.

As both the exhibition and the catalogue are about to come to fruition, I am also much indebted to Ellen Cunningham, Exhibition and Outreach Manager, for co-ordinating all facets of exhibition planning; Jennifer Kuchta for her communications expertise; Margaret Barry for her sensitive editing of the text in the catalogue; and Alan Brownoff, University of Alberta Press, for his creative and elegant design.

Dr. Ka Bo Tsang
Curator of Chinese Painting
Royal Ontario Museum

Chronology

Xia dynasty, ca. 2100–ca. 1600 B.C.

Shang dynasty, ca. 1600–ca. 1100 B.C.

Zhou dynasty, ca. 1100–256 B.C.
Western Zhou, 1100–771 B.C.
Eastern Zhou, 770–256 B.C.
Spring and Autumn period, 770–476 B.C.
Warring States period, 475–221 B.C.

Qin dynasty, 221–206 B.C.

Han dynasty, 206 B.C.–220
Western Han, 206 B.C.–8
Xin, 9–24
Eastern Han, 25–220

Three Kingdoms, 220–265

Jin dynasty, 265–420
Western Jin, 265–317
Sixteen Kingdoms, 304–439
Eastern Jin, 317–420

Southern and Northern dynasties, 420–589
Liu Song, 420–479
Southern Qi, 479–502
Liang, 502–557
Chen, 557–589
Northern Wei, 386–535
Eastern Wei, 534–549
Western Wei, 535–557
Northern Qi, 549–577
Northern Zhou, 557–581

Sui dynasty, 581–618

Tang dynasty, 618–907

Five dynasties, 907–960

Liao dynasty, 907–1125

Song dynasty, 960–1279
Northern Song, 960–1127
Southern Song, 1127–1279

Jin dynasty, 1115–1234

Yuan dynasty, 1271–1368

Ming dynasty, 1368–1644

Qing dynasty, 1644–1912

Republic of China, 1912–

People's Republic of China, 1949–

BRILLIANT *Strokes*

Chinese Paintings from the Mactaggart Art Collection

Shen Zhou (1427–1509)
Farewell Party for Wang Ao

Hanging scroll
Ink and touches of colour on paper
Ming dynasty, 1492
146.3 x 36.5 cm

University of Alberta Museums
Mactaggart Art Collection
2004.19.23
© University of Alberta Museums

THIS PAINTING depicts several scholars gathered in a riverside cottage built near a group of trees. Across the river are tall hills that recede into the far distance. Inscriptions by Shen Zhou, the creator of this work, and inscriptions by two friends are at the top.[1]

On this rare occasion old friends have a hearty chat.[2]
All cannot help lamenting over the passing of the years.
Aged with thinning hair at the temples,
[We watch the reflections] of tens of thousands of houses
 floating in the autumn water.
Though already drunk, we still call for more wine.
When the boat is about to depart [he] has to lean on [its side].
In these days the rivers and lakes are full of trouble.[3]
We all understand that though he may be far away, his heart
 will linger here.

[Composed on] the 29th day of the 9th month in the year renzi of the Hongzhi period (1492). Mr. Wang, the Imperial Instructor, was about to embark on a trip. Wen taipu *gave him a farewell party.*[4] *I composed a poem in response to Mr. Wang's verses written while he was crossing Lake Tai and inscribed it on this painting as a parting gift for him.* —Shen Zhou[5]

———

Being separated long and far apart by the rivers and lakes,
We think of one another while months turn into years.
Inebriated, we treasure tonight's farewell party.

As we gain in years, we feel we have led but a floating life.[6]
Take care, traveller who has reached Yingzhou,[7]
[For now at least] do take shelter tonight on this boat moored
 by the ravine.
The night-watch begins to diminish, yet we cannot bear
 to part.
Surely our dallying cannot be just for the sake of the wine?
 —Wen Lin[8]

———

We sit side by side, all dressed in formal clothing.
[Yet, our gathering is] no less elegant than [the literati's of] the
 Jin period.[9]
As tall mountains take shape in the picture,
And lakes appear beyond the door-sill,
Let's down a gallon of wine.
So that the boat would remain tied [a little longer].
The person who is being remembered today,
Hardly realizes that it is him who wishes to stay longer.

Jizhi, the Imperial Instructor, passed by Wuxian (present-day Suzhou) when he went to supervise the civil-service examination for the candidates of the southern provinces. He spent more than ten days to see friends and relatives. This was the painting with a poetic inscription given to him by Shen Shitian at the farewell party given by Wen taipu. *I also composed a poem using the same rhymes. My feelings have been embodied in the final couplet.* —Wu Kuan[10]

These inscriptions shed light on the nature of the occasion and the identity of the participants. A farewell party was organized by Wen Lin (1445–1499) in honour of Wang Ao (alias Jizhi, 1450–1524) in the autumn of 1492.[11] Shen Zhou and Wu Kuan (1436–1504) were among the invited guests. This was no ordinary gathering, for the participants represented the most distinguished elite in Suzhou, a cultural centre in the lower Yangzi region. Shen Zhou was a respected scholar-painter. Wen Lin was an official posted in Nanjing. Wu Kuan (1436–1504) and Wang Ao both worked in the Hanlin Academy in the capital. Both men also took part in the compilation of the *Xianzong shilu* (Veritable Record of the Emperor Xianzong). All of them shared a common interest in literary and artistic creation as well as collecting antiquities. No doubt they had much to talk about and to reminisce over before the imminent departure of Wang Ao.

Stylistically this work shows Shen Zhou's indebtedness to the Yuan masters, in particular Huang Gongwang (1269–1354), Ni Zan (1306–1374),[12] and Wu Zhen (1280–1354), whose works he studied diligently. Ni Zan's influence, for instance, is obvious in the structure of the composition—the distinct separation by a river course of the foreground elements from those in the distance—and the composite motif of sparse trees. Yet, differing from Ni Zan's standard design, Shen Zhou allows the two trees at the centre of the foreground to extend upward, the top of one of them pointing at the base of the tallest mountain in the background. Together, the trees and the mountain evoke the feeling of a surging force, which is quite becoming to the painting's narrow vertical format. This axial arrangement not only bridges the foreground and background components but also creates a sense of visual stability. Huang Gongwang's mark is evident in the relaxed and varied contours of the mountains and rocks.

3

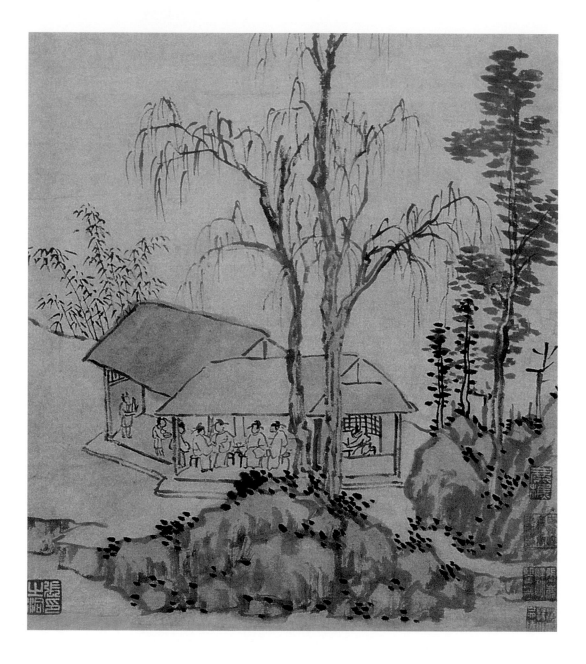

The blunt, broad, and moist texture strokes applied to the earth forms summon up similar brush idioms favoured by Wu Zhen.

Besides synthesizing the salient features of his venerated models, Shen Zhou also relies on other brush idioms to make this work interesting. Clusters of dark ink dots, for example, are rendered with a blunt brush tip in a spontaneous manner. They are dispersed along selected contours of the earth forms, suggesting plant growth as well as unifying the composition. Contrasts arising from varied ink tonality and different images of foliage add to the scene's visual diversity.

The most interesting detail in this painting has to be the scene of the farewell party. Although detailed facial features of the figures have not been painted, the postures of the seated scholars impart a sense of engrossed, animated conversation. While attendants stand by ready to fill guests' wine cups, it is tempting to see the isolated seated figure on the right as Shen Zhou himself—intent on completing this painting so that he and other friends can write their freshly composed poems on it and let Wang Ao carry it away when the party has ended. The urgency to finish the artwork is likely responsible for some of the rather sketchy strokes used to define the rocks' texture.

Detail showing Wang Ao and friends chatting while Shen Zhou (right) paints this visual record of their gathering.

Wen Zhengming (1470–1559)
River Landscape

Handscroll
Ink on paper
Ming dynasty, 1499
17.4 x 125.3 cm

University of Alberta Museums
Mactaggart Art Collection
2004.19.13
© University of Alberta Museums

THE SCROLL opens with a secluded valley that has a cluster of houses nestled in a tree grove. A path passing by these houses winds its way into the depths of the mountains from which two woodcutters are just coming out. They are carrying bundles of wood and heading in the direction of the houses, apparently returning home after a solid day's work. As the viewer moves on towards the left, the enclosed surroundings change to a broad river scene where spits of land with trees and houses in the middle ground are linked by a plank bridge. Beyond, rolling hills screen the horizon.

In the next section, a voluminous mountain rises from the lower border of the painting. Its top reaches beyond the upper limit of the painting proper. A path hewn out of its slope on the right leads down to another cluster of houses built over the edge of the river. They are sheltered snugly under large trees with luxuriant foliage. The left side of the mountain is steep. Rows of trees stand as a sentry mid-way along its cliff face. One of them bends downward to draw attention to a pavilion perched on a flat-topped boulder, a look-out presumably accessible also by the narrow path. If viewers imagine themselves gazing afar from the pavilion, they are greeted by an expansive vista consisting of land spits with houses half concealed by lush trees, two skiffs moving along the river, and distant mountain ranges girdled with drifting mist.

At the end of this idyllic scene is an inscription by Wen Zhengming, which indicates that the work was completed on the sixteenth day of the ninth month in 1499. Wen Zhengming's father, Wen Lin (1445–1499), was a good friend of Shen Zhou (1427–1509), the most respected literatus painter in art circles of the time.

In 1489, Wen Lin arranged to have Wen Zhengming study painting under Shen Zhou. Wen Zhengming was thirty years old when he painted *River Landscape*. Through his teacher's instruction, he possessed the knowledge and the skills passed down by Song and Yuan masters and he was quite ready to embark on his own artistic career.

As an example of Wen's early works, this painting reflects his close tie to Shen Zhou. Traits of his teacher's later work, which are evident in *River Landscape*, are the careful design, detailed execution, rich brush idioms, well-balanced composition, tranquil atmosphere, and a genuine sense of rapport with nature.

The painting is infused with various elements of contrast that generate visual interest and a feeling of diversity. The composition, for example, is structured as two equal halves. Within each half, one side is dominated by dense pictorial elements; the other side consists of a few motifs that are spaced far apart. By repeating this scheme of "solid" versus "void," the scenery alternates from land to river twice, creating a rhythmic pattern

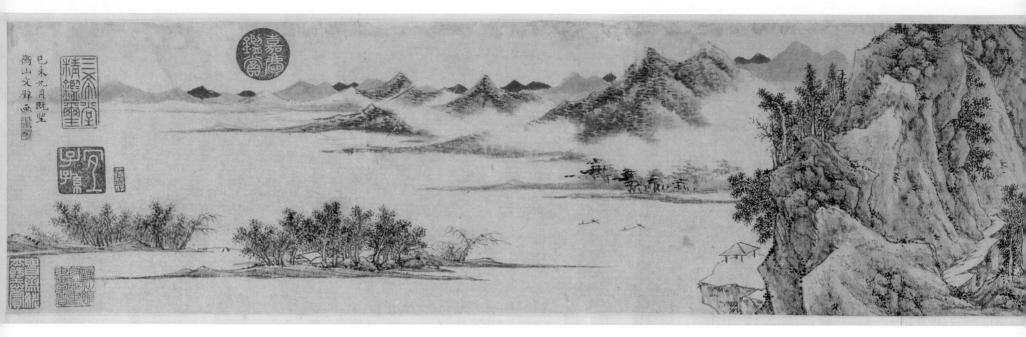

and an even flow. The four compartments are also subtly linked together by land spits in the middle ground and mountain ranges in the background. Similarly, other devices, such as the zigzag path at the beginning of the scroll, the plank bridge, the footpath in mid-section, the land spits, and the tiny skiffs are all carefully planned to guide the viewer to travel through the scene stage-by-stage and to savour the different settings with a fresh perspective.

Visual contrast is also embodied in ink and brush techniques. While the tonal gradation varies from the palest grey to jet-black, the ink is applied in an equally interesting manner. It appears light and dry in areas where it is being rubbed on sparingly with the side of the brush tip, as seen in the rock surfaces; dark and moist as in the tree trunks and foliage; or as broad washes for defining the silhouette of the distant mountains. A full range of brush idioms, which vary from firm or relaxed lines to dots of

many shapes and sizes, has also been employed to achieve the same aim.

The painting is followed by 14 colophons. One was written by Wen Zhengming in 1531, in which he expressed astonishment that thirty years had elapsed since he executed the scroll and in spite of the passage of time, he feared he was none the wiser. Others were written by Wen's mentors, Shen Zhou and Wu Kuan (1436–1504); the husband of Wen's second cousin, Yang Xunji (1458–1546); son, Wen Peng (1489–1573); friends, Zhu Yunming (1461–1527, two colophons by him), Wang Chong (1494–1533), Wang Guxiang (1501–1568), Lu Shidao (1517–1580), Xu Chu, and Zhang Fengyi (1527–1613); and students, Chen Chun (1483–1544) and Peng Nian (1505–1566). These were either poems or comments expressing admiration of Wen's high moral conduct, lofty ideas, painting talents, and the wonderful qualities of this work. While some likened him on a par with Li

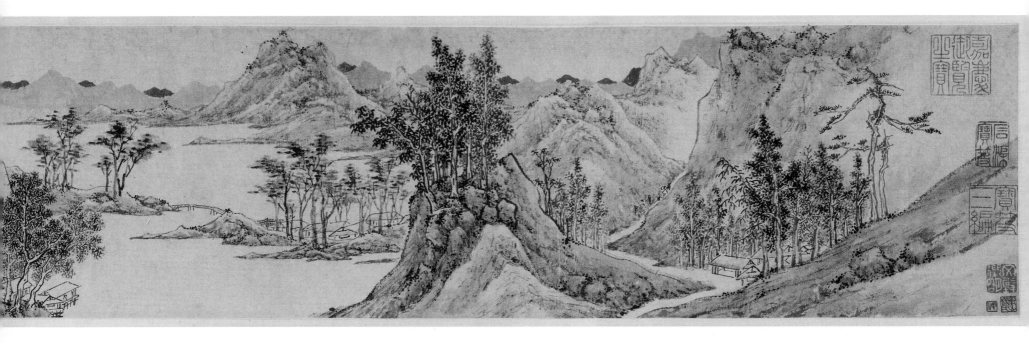

Bottom: Detail showing two colophons by Shen Zhou (right) and Wu Kuan (left).

Cheng (919–967) and Jing Hao (ca. 870/80–935/40), others extolled him for having grasped the essence of the brush manners of Dong Yuan (d. 962) and Wu Zhen (1280–1354) or being able to approach antiquity by synthesizing the characteristics of Dong Yuan, Juran (act. ca. 960–985) and the masters of the late Yuan period.

Although it is not clear who owned this scroll after its completion, based on the dated colophons of Peng Nian and Lu Shidao who claimed to have seen this painting in the studio of Yuan Biao, we are certain that it was in Yuan's possession between 1528 and 1545.[1] Yuan Biao was a government official who retired to Suzhou after his last posting as Assistant Sub-prefect of Linjiang.[2] Apparently he and his brothers were intimate friends of Wen Zhengming. In 1530, Wen Zhengming, his son Wen Jia, and his nephew Wen Boren each did a painting of Yuan Biao's new studio, Wende zhai (Hearing Virtue Studio). Many people in Wen Zhengming's coterie also composed

poems and essays extolling this small studio that had a congenial atmosphere.[3]

Similar to the fate of all works of art, the ownership of this scroll continued to change. In the Qing dynasty, it found its way to the imperial collection during the last years of the reign of the Qianlong emperor (1736–1795).[4] As a result, it has been recorded in the *Shiqu baoji sanbian*, a catalogue of paintings added to the imperial collection since 1793.[5]

Ma Shouzhen (1548–1604)
Orchids, Bamboo, and Rocks[1]

Handscroll
Ink and colour on paper
Ming dynasty, dated 1566
29.5 x 127.4 cm

University of Alberta Museums
Mactaggart Art Collection
2004.19.56
© University of Alberta Museums

MA SHOUZHEN was a renowned courtesan in Jinling (present-day Nanjing) during the latter part of the Ming dynasty. Although she was not a ravishing beauty, she made a name for herself in the pleasure quarter by her outstanding accomplishments in a wide range of literary and artistic pursuits, including: singing, dancing, acting, composing lyrics, poetry, prose-writing, painting, and calligraphy. She was also well known for her generosity, cavalier spirit, and unconventional behaviour. It is said that on many occasions she readily pawned off her hairpins and jewellery to raise money for young admirers who were broke.[2]

It is also said that she once expressed the desire to marry her paramour after he had saved her from a legal snare. Her paramour was Wang Zhideng (1535–1612), a popular poet and calligrapher. Although her wish was not gratified, the couple met again as Wang turned seventy years old. To honour him, she gave him a lavish birthday party. The feast, which lasted almost a month, took place in the Feixu yuan (Garden of Flying Willow Catkins). Guests drank and wrote poems while being entertained by several scores of beauties provided by Ma Shouzhen.[3]

A fairly large number of paintings by Ma Shouzhen have survived.[4] Dated works begin in 1563, when she was sixteen years old and end in 1604, the year she died. These, together with her undated paintings, show her lifelong artistic development. Bamboo, orchids, and rocks were

clearly her favourite subjects. Only rarely did she depict lotuses, narcissi, butterflies, and landscape.

Bamboo and orchid are two plants especially esteemed by scholars. This is because they were easily available for study by a large concentration of the intelligentsia who lived in the temperate Jiangnan region of east central China. Moreover, they were particularly suitable for representation by calligraphic brushwork, a painting method that could easily be grasped by the scholars who had been thoroughly trained in the art of writing.

Those who became versatile in painting these plants could quickly complete a work during a literary gathering—a definite advantage over, for example, landscape or figural subjects. More importantly, both plants have been associated with virtues embodied by the *junzi*, the Confucian ideal of a cultivated man. The bamboo, for example, symbolized modesty and fortitude on account of its hollow stem and its characteristic bending without breaking in adverse conditions. The orchid was deemed an appropriate emblem of loftiness and elusiveness because of its subtle fragrance and its preferred secluded habitat, such as growing in valleys.

Ma Shouzhen developed a penchant for the orchid in her youth. This is borne out by her earliest dated work. Not only does it depict the orchid, it also bears a signature that includes both her proper name and her style name, Xianglan. Xianglan means "an orchid of the Xiang

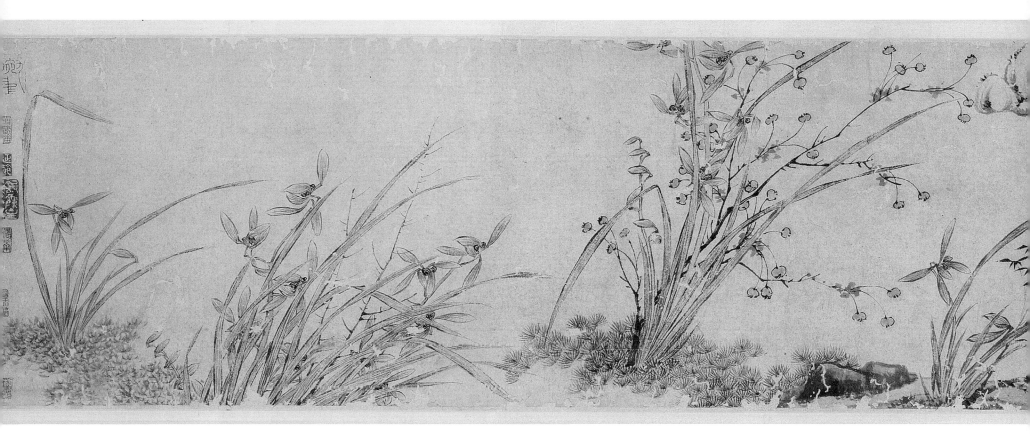

Detail of the left portion of the handscroll.

River." It evokes a clear association to both Qu Yuan (340–278 B.C.), the statesman and poet from the Chu state during the late Warring States period who praised the purity and loftiness of the orchid, and the legendary devotion of the two consorts of Shun.[5] By adopting this name, Ma Shouzhen probably wished to project herself as the embodiment of a noble character and of a true love.[6] Her preference for creating paintings of orchids, therefore, was not just to please her intellectual patrons but also for self-expression.

This painting depicts nine groups of orchids. They are arranged in an interesting layout. Eight clusters are positioned along the lower border, with patches of grass, rocks, and a gentle slope suggesting a natural environment. One clump showing only the bottom half of the plants surrounded by large and small rocks is located in the mid-section along the upper border of the painting. The distance that separates this clump from the foreground clusters gives a sense of depth to the scene.

Although the orchids form the main focus, each cluster is treated differently. The clusters instill a feeling of variety within sameness. In most cases, each is combined with one or two of the following secondary pictorial elements: the *lingzhi* (fungus of immortality), three kinds of bamboo,

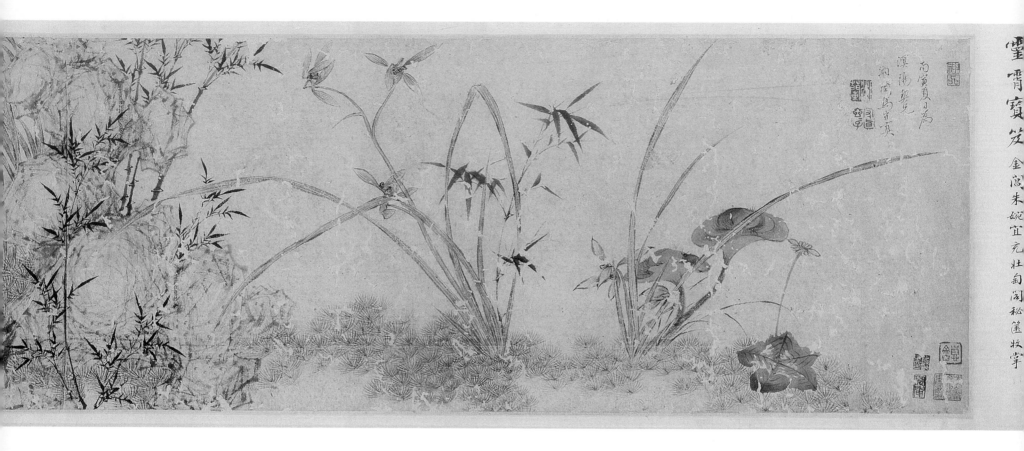

Detail of the right portion of the handscroll.

a ground-covering plant with compound leaves, mosses, and thorny shrubs that are either bare or still bearing berries.

Variety, too, is evident in the painting methods. While the orchids are predominantly delineated with outlines, three clumps are depicted growing together with delicate stems of bamboo that are rendered with crisp ink strokes. One small clump of orchids, positioned at mid-section of the painting and to the left of the largest group, is also represented in the *mogu* or boneless manner. Together with the spindly bamboo, they generate a visual contrast that helps to alleviate the feeling of repetitiveness. The rocks, in size, shape, and method of representation, also

show the painter's similar attempt to make the same details look a little different from one another.

An element of surprise has also been worked into *Orchids, Bamboo, and Rocks.* Normally, one rarely finds a dandelion included in this special genre of work. An image of this weed can be seen at the beginning of the painting. Since the dandelion is a lowly weed, its very presence sets the underlying tone of contrast that prevails over the whole painting. The humble weed also plays another role. The gentle curve of its flower stem evokes the image of a maid bowing lightly to welcome in a viewer. With its floret almost touching the larger *lingzhi*, it seems to be very eager to introduce the viewer to the first cluster of orchids.

From this cluster, each subsequent clump is subtly connected by the graceful sweep of the orchids' leaves. The viewer's gaze is directed to move effortlessly through the scene, a visual experience comparable to watching a parade of dancers interacting harmoniously with one another during a performance.

According to Ma Shouzhen's inscription, this painting was done on a summer day in 1566 for one of her patrons, a sworn elder brother named Mingyang. Its sophisticated compositional planning and painting techniques, as well as the fact that the Indianapolis Museum of Art owns an identical version with a 1604 date, raise doubts about its authenticity.[7] While the 1566 version certainly demonstrates an amazing degree of artistic accomplishment for a seventeen-year-old amateur, the 1604 version, executed forty years later if the inscription were to be trusted, is not without its doubts either. The stiffness in the articulation of the orchids' leaves, the regularity inherent in the patternized grass and bamboo leaves, and the wider spacing between the orchid clumps, to name a few items, also pose questions about the artistic skills of a seasoned painter. Both versions, therefore, require further research.

This painting has seven colophons written respectively by Lu Yiqian (1785), Dong Bin (1785), Zhang Yanchang (1785), Wang Wenzhi, Xi Gang, and Hu Bicheng (1919).[8] They either praise the fine quality of Ma Shouzhen's orchid paintings, comment on her fame and unique character, or record the important happenings in her life. Seals of collectors impressed at the beginning and end of this painting indicate that it has been in several collections in Guangdong province, including those of Pan Shicheng (*juren* in 1832), Pan Yanling (act. 1851–1874) and his third son, a certain Mr. Zhang, and Pei Jingfu (1854–1926).

Among these collectors, the better known are Pan Shicheng and Pei Jingfu. Pan Shicheng's residence, called Haishan xianguan (Immortals' Abode in a Mountain by the Sea), was famous for its luxurious architecture and its collections of books, paintings, and calligraphy. Pei Jingfu wrote his evaluation of Ma Shouzhen's art in the space separating Ma's painting and the laudatory colophons. He also added a note intimating that he had just acquired another handscroll by Ma which depicted narcissi using the outline technique. He thought its artistic quality was so wonderful that he kept it and the painting *Orchids, Bamboo, and Rocks* in his studio called the Zhuangtaoge. Pei Jingfu devoted five years to compile a catalogue of the paintings and calligraphy in his collection and important works he had seen in other collections. Although the catalogue was completed in 1923, it was not published until 1937, eleven years after Pei's death. In this set consisting of 22 *juan* (volumes), Ma Shouzhen's narcissi handscroll is the only recorded work by her.[9] For some unknown reason, *Orchids, Bamboo, and Rocks* has not been included.

4

Chen Zhuan (1678–1758)[1]
Flowers, Fruits, and Fish

Album of 10 leaves
Ink and colour on paper
Qing dynasty, dated 1722
30.1 x 38.4 cm (each leaf)

University of Alberta Museums
Mactaggart Art Collection
2004.19.58.1–10
© University of Alberta Museums

Right: Leaf no. 1, Apricot blossom

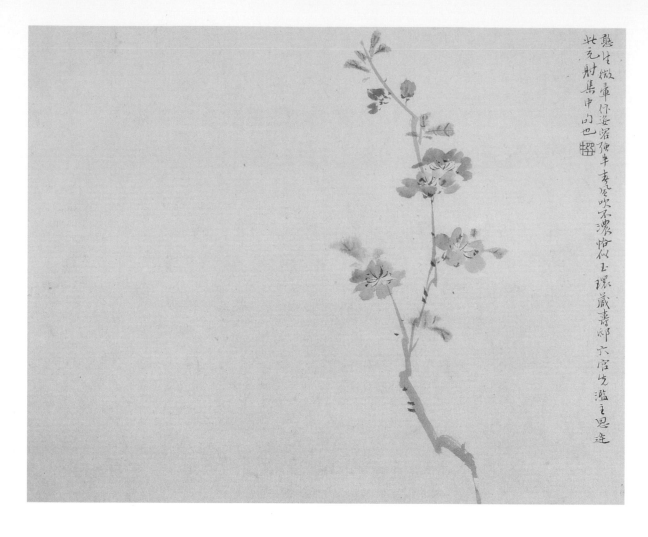

1 **Apricot blossom**
Looking silly with a faint blush on their beguiling faces,
Even the spring breezes cannot coax most of them to put on
more colour.
Just like [Yang] Yuhuan, hiding in the residence of
Prince Shou,[2]
[Waiting for] all the court ladies being favoured by the
emperor [before she finally] became the object of his
fascination.
—This is composed to guess [the meaning of]
a line in a collection [of poems].

2 **Pear blossom**
The pear blossom is truly superior,
Looking elegant no matter how it is groomed.
—Verse by a Yuan poet.

3 **Peach blossom**
This liberated slave was originally a ravishing beauty.
The Emperor [of Heaven] appointed her to be the head of
all flowers.
With her jade-like hands she wielded a pair of golden scissors,
Cutting the rain that fell in the Jiangnan region in the third
month into tiny droplets.
[People's] dreams were tinted with the colour scarlet and
pervaded with a seductive scent.

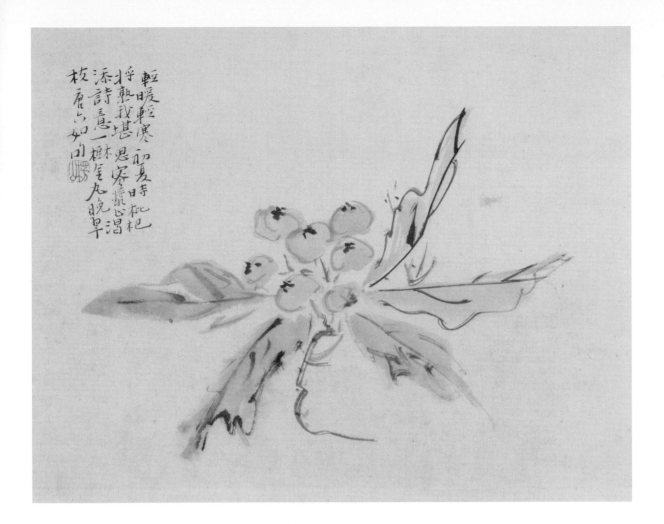

Leaf no. 4, Loquats

Besides the gauze curtains red candles burning all night long
 also emit a scent of wax.
A pair of birds with green and yellow plumage,
Chirp ceaselessly as if they were begging spring earnestly to
 stay longer.
The steed of the God of Spring neighed while galloping on the
 lush grass.
This iron-grey horse had all the intention to run away together
 with the east wind.

4 **Loquats**
 In the early summer when it is neither warm nor cold,
 I think of the loquats that will soon ripen.
 Their sweet juices quench [my] thirst and inspire [my]
 poetic thoughts.
 A [remarkable] tree laden with golden balls on green branches.
 —*Poem by Tang Liuru* [3]

5 **Lotus**
 Summer heat is dissipated for good by this flower.

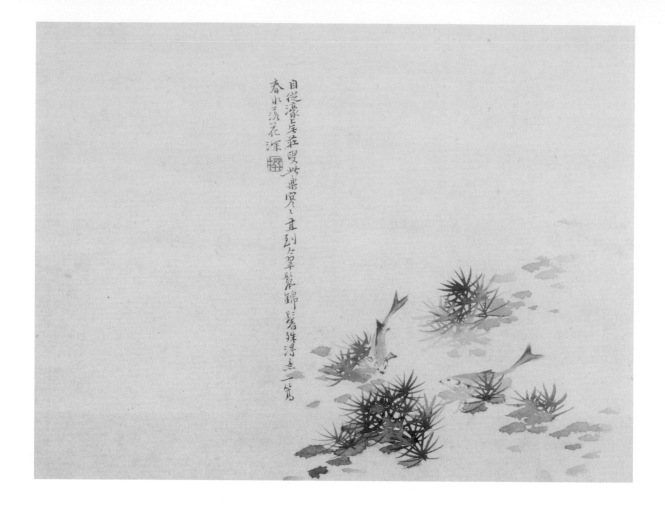

6 Buddha's hand citron and melon

Only these two fruits have fragrances quite different from
those emitted by flowers.

7 Swimming fish

Since there is no more old Mr. Zhuang on the bank of
River Hao,[4]
[Few understand] this happiness until now.
Lovely indeed are the fish with emerald and colourful fins,
[As they glide] in the deep spring water strewn with
fallen petals.

8 Luffa

I love this green handle of a flywhisk.
Its curved cylindrical shape is just right for holding,
When yellow flowers issue in late autumn,
[They] flutter [in the wind] like butterflies.

9 Narcissus and rock

The most subtle and wonderful among flowers,
The most pure and refreshing among fragrances.

Leaf no. 9, Narcissus and rock

10 **Prunus**

I received a lovely invitation early in the morning.
From the east end of the city where the ground was marred
 with tracks made by cart wheels.
The prunus blossoms in the garden had burst through the
 coldness of spring.
Changing their colours to almost pure white.
In leisure time we searched for interesting scenic spots.
In indulging moods we refused to abide by social conventions.
In the little studio sunlight [seemed to] stay longer
While red wine was passed round and round.
The delicate flowers emitted a wonderful fragrance,
Exquisitely beautiful, yet so subtle that it left not a trace.
When the setting sun cast soft shadows,
The whole ground became covered with [what appeared to be]
 picture frames.

It was time to leave, yet we lingered again and again.
[For] each morning the wind would blow in a different way.
 —Composed during the second month
 of the year renyin (1722) when friends gathered
 at the Cun (Existence) Garden.

CHEN ZHUAN'S courtesy name was Yuji and his style
name was Lengshan. He was a native of Ningbo in
Zhejiang province but lived in Hangzhou. He was highly
regarded by his contemporaries for his poetry, calligraphy,
painting, and connoisseurship in art. It is not known
exactly when he moved to Yangzhou, the most affluent
city in the Jiangnan region during the eighteenth century.
What is known is that similar to many artists and men
of letters who were drawn to this cultural centre, he was
supported by various wealthy scholar-merchant patrons

during his stay. His patrons included a Mr. Xiang, who owned a very substantial collection of bronze vessels and rare books; Cheng Mengxing (1679–1755), who was the owner of Xiaoyuan (Bamboo Garden); and Jiang Chun, who invited both Chen Zhuan and his son-in-law, Xu Bin, also a painter, to stay in his estate called the Kangshan caotang (Grass Hut on Mount Kang).

In 1757, when Chen Zhuan's health declined, he expressed a desire to return to Hangzhou. A considerate patron bought land in Chen Zhuan's hometown and prepared a burial plot for him. Chen Zhuan passed away soon after its completion, leaving for posterity several collections of poems and paintings that he did for friends and patrons.[5]

Chen Zhuan has been described as a man who had lofty ideals and preferred to distance himself from conventional social affairs. He was recommended, with other well-known scholars, such as Jin Nong (1687–1773) and Ding Jing (1695–1765), to sit for the prestigious *boxue hongci* examination in 1736. Similar to Jin and Ding, he declined the honour.[6]

From the poems he exchanged with or dedicated to friends, it seems that he was often in the company of wealthy or influential people. Counted among these powerful people were Ma Yueguan (1688–1755) a major patron of scholars and artists; the scholars Hang Shijun (1696–1773) and Cheng Ming (act. first half of 18th century); high officials Wang Ch'ang (1725–1806) and Shen Tingfang (1702–1772); and Jin Nong, a poet, painter, and calligrapher.

The subjects painted in this album are flowers and fruits, the only exception being two fish swimming among aquatic plants. Although the subjects differ, they all share certain salient features in compositional design. In each case, for example, the best side of the subject is presented in a close-up view. The image occupies only half of the painting proper, with the other half being left empty as a subtle element of counter-balance. This contrasting "solid" versus "void" relationship may be seen in a left-right or up-down arrangement. Two leaves depict a cluster of loquats and a Buddha's hand citron with a melon, respectively. These fruits are at the very centre of the painting proper, which is a position that asserts immediate attention. The inscriptions, too, are relied upon to visually enhance the appearance of the pictorial image whilst describing or amplifying its significance. The poetic content engenders an air of exquisite elegance for the painted subject.

Outline and *mogu* (boneless, achieved by solely relying on the use of ink or colour washes for representation) techniques have been used, either singly or combined for representation. They reflect the painter's sensitive observation of his subjects, his ability to grasp and express their inner essence rather than a formal likeness. This spontaneity captures the painter's fleeting moments of inspiration. Calligraphic potential, too, has been played to the full in some works. Especially successful are the two leaves that depict a cluster of loquats (no. 4) and the luffa (no. 8). The former shows the flying-white feature typical of the *caoshu* or cursive script for the broken branch and some of the serrated leaf edges and veins. The latter displays fluid lines also typical of the *caoshu*. They form flowing curves and loops to delineate the ever-extending springy vines. Both are so enhanced by such lively strokes that one can almost visualize the ecstatic joy of the painter when he found the right subject and medium to unlock his creative energy.

Wang Yu (act. ca. 1680–after 1750)
Admiring an Autumn View at Sunset

Hanging scroll
Ink and colour on paper
Qing dynasty, 1738
141.2 x 74.9 cm

University of Alberta Museums
Mactaggart Art Collection
2004.19.77
© University of Alberta Museums

Ten-thousand-foot tall precipices tower over a clear waterfall.
A pavilion [lit by] the setting sun is shrouded by cool
 evening clouds.
The green mountains are still, the red dust no where to
 be seen.[1]
Pray lean on the balustrade [to admire] the wonderful autumn
 view [is my] advice.
 —Painted in mid-spring of the year wuwu *(1738)*
 for Donglao, a venerable senior classmate, by Wang Yu.

WANG YU'S deep respect for Donglao is evident in the
dedication. His reverence is also expressed through the
subject of this painting and the quality of its execution.
The landscape's exceedingly tall pines and majestic moun-
tains are symbolic of his high esteem for Donglao's lofty
character. The figure who is admiring the mountain view,
which is bathed in the last glow of sunset, is another of
Wang's efforts to honour the recipient of this work. The
figure is Donglao and he is alone in the scene.

 Wang Yu was related to two of the Four Wangs, protag-
onists of the orthodox school who formed a dominant
force in the artistic circles of the early Qing period.[2] He
was the third cousin of Wang Yuanqi (1642–1715), who in
turn was the grandson of Wang Shimin (1592–1680). It is,
therefore, not surprising that Wang Yu continued in the
footsteps of his distinguished forebears.

 According to *Dongzhuang lunhua* (Discourses on Painting
by Dongzhuang), Wang Yu's only published small collec-
tion of notes regarding his observations and experiences
related to painting, he acquired the rudiments of painting
at a young age. As an adult, he travelled to the capital,
Beijing, to further his artistic studies. For three years he
received instruction from Wang Yuanqi. During this time,
he was able to master his mentor's painting techniques
and won Wang Yuanqi's effusive approval.[3]

 One source claims that Wang Yuanqi's paintings were
in such great demand that he set up a painting bureau
and let Wang Yu supervise its business. Whenever people
placed orders, Wang Yu would do most of the painting
so that all Wang Yuanqi needed to do was apply a few
finishing touches.[4] This joint venture, if indeed it was true,
certainly reflects the cordial relationship between teacher
and student and the high regard the senior Wang had for
his young protégé. The same source also reveals that after
Wang Yu returned home in Taicang in Jiangsu province his
fame spread far and wide. Many people sought him out in
the hope of obtaining a painting by him.

 In *Dongzhuang lunhua*, Wang Yu imparts useful tips to
those who wish to strive for better performance in their
artistic pursuits. He says that artists should constantly
review their work for shortcomings and seek improve-
ment by learning from the merits of other artists' work.

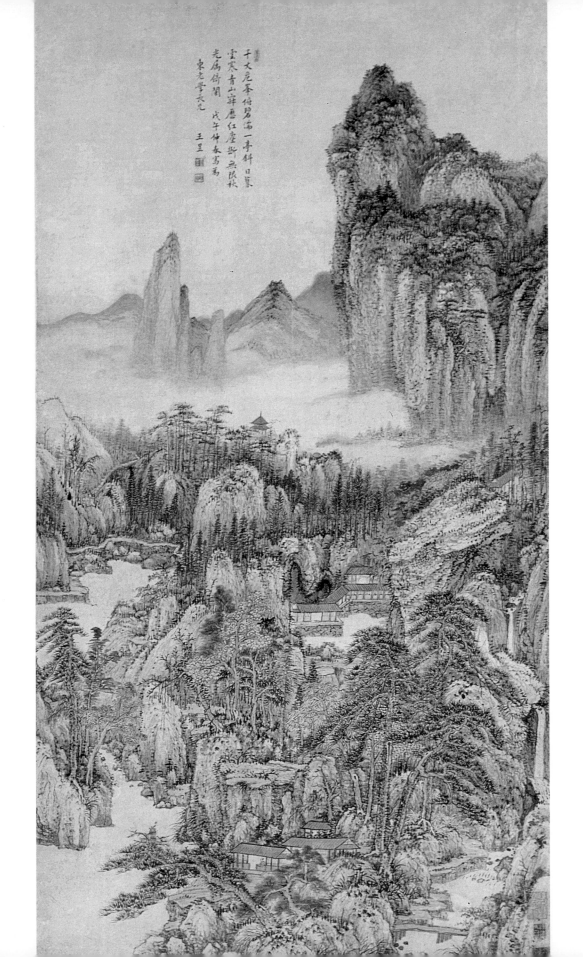

To this end, visiting collections noted for famous works and trying to borrow them for close study would be advantageous. Travelling widely to observe nature in its many nuances and to broaden one's scope is important.[5] Speaking from personal experience, he advises that before setting brush to paper one should nurture a creative mood, by way of gazing at floating clouds or murmuring streams, admiring flowers and birds, taking a stroll, reciting poems, lighting incense, or sipping a cup of tea. As soon as one feels inspired, one can immediately set down ideas on paper and stop when ideas run out. One can then continue to work on it whenever the mood recurs. In this way, Wang Yu asserts, the finished painting will embody an animated life force. It will also stand above the ordinary.[6]

This painting is a living example of what he believed in. He studied assiduously under Wang Yuanqi, absorbing Wang's deep knowledge in artistic matters. While in Beijing, he also had many opportunities to study excellent ancient paintings in well-known collections. He travelled as far as Shaanxi province to see the high and rugged mountains. In painting this detailed work, he must have spent much time pondering over possible designs and techniques. The profuse brush idioms also testify to his painting method, which entailed a protracted period of time for completing the work in hand.

Admiring an Autumn View at Sunset reveals Wang Yu's influence by Wang Meng (1298–1385), one of the Four Great Masters of the Yuan period. This influence is obvious in both the dense composition and the furry texture of his surfaces.

However, Wang Yu's inner vision differs markedly from his distant model. Wang Meng is known for his passion for crowding his paintings with heaving cliffs and distorted rocks that seem to pulsate with an uninhabitable inner force. Wang Meng also had a penchant for reducing space to a minimum, forcing the viewer to savour the tactile qualities of his tightly organized motifs.

Wang Yu, on the other hand, saw nature as much friendlier. Although his trees, mountains, and rocks are densely disposed, he makes sure that they are organized and relate to one another logically. He also introduces space (waterfall, inlets of a stream, drifting mist, sky) around these solid forms to alleviate their heaviness. While Wang Meng's paintings are concerned with evoking the height rather than the depth of a scene, Wang Yu emphasizes both. The vision that Wang Yu encapsulated for Donglao is that nature is splendid, vast, calm, and benevolent—suitable for a scholar to take refuge when he desires to escape the fettered routine of urban life.

Yuan Yao (act. 1720–1780)
Summary Retreat at Lakeside Village

Yuan Yao (act. 1720–1780)
Summer Retreat at Lakeside Village

Hanging scroll
Ink and colour on silk
Qing dynasty, 18th century
160.5 x 57.5 cm

University of Alberta Museums
Mactaggart Art Collection
2004.19.21
© University of Alberta Museums

YUAN YAO and his father Yuan Jiang (act. 1680–1740) were professional painters.[1] Only minimal information about their lives has been recorded due to their low status among the intelligentsia, even though they were painters of some renown in their native place Yangzhou.

What is known about Yuan Yao's activities in his hometown is limited to his connection with a wealthy salt merchant named He Junzhao, a native of Linfen in Shanxi province. He Junzhao owned a villa in the outskirts of Yangzhou named Heyuan (He Garden). In 1744, after adding several more buildings to his garden, He Junzhao invited Yuan Yao and other guests to compose poems to celebrate the occasion. Two years later he commissioned Yuan Yao to paint twelve views of the most scenic spots in the garden.

In 1747, He Junzhao decided to return to his hometown of Linfen. As a farewell token, Yuan Yao and another artist named Zhu Zhen painted parting scenes for him while other well-wishers wrote poems that expressed their sadness over his departure.[2]

The bulk of the paintings executed by Yuan Jiang and Yuan Yao existed mainly in Shanxi province during the early years of the Republican period. Scholars generally believe that for many years, father and son worked for a Wei family in the provincial capital, Taiyuan.[3] They produced paintings of all sorts, including handscrolls and albums for pure appreciation and hanging scrolls,

screens, facings for lanterns and door- or window-partitions suitable for interior decoration.[4] Since few paintings depict specific scenes of Yangzhou after 1747, it is also believed that following the departure of He Junzhao, Yuan Yao, too, travelled to Shanxi province to make a living.[5]

The two Yuans' northbound trips are so shrouded in mystery that there is also a rumour that they were employed as court painters in Beijing.[6] Although it is not certain when Yuan Yao returned to Yangzhou, a group of four dated paintings by him, entitled *Historical and Scenic Places in Yangzhou*, indicate that he was home again at least by 1778, if not earlier.[7]

Yuan Yao followed his father's painting style very closely. Their works are so similar that if there were no signatures it would be very difficult to tell one from the other. Yuan Jiang's style was basically academic, stemming from Tang, Song, and Yuan traditions represented by Li Sixun (651–716) and his son Li Zhaodao (act. ca. 713–741), Fan Kuan (ca. 950–1026), Guo Xi (ca. 1020–1090), Li Cheng (919–967), Li Tang (ca. 1066–1150), Ma Yuan (ca. 1140–after 1225), Xia Gui (ca. 1180–1224), and Wang Zhenpeng (act. first half of fourteenth century).

The two Yuans were well known for painting magnificent mansions set among grandiose landscapes, such as fantastic craggy mountains, sumptuous trees, and broad rivers. Some of the scenes were real places, but many

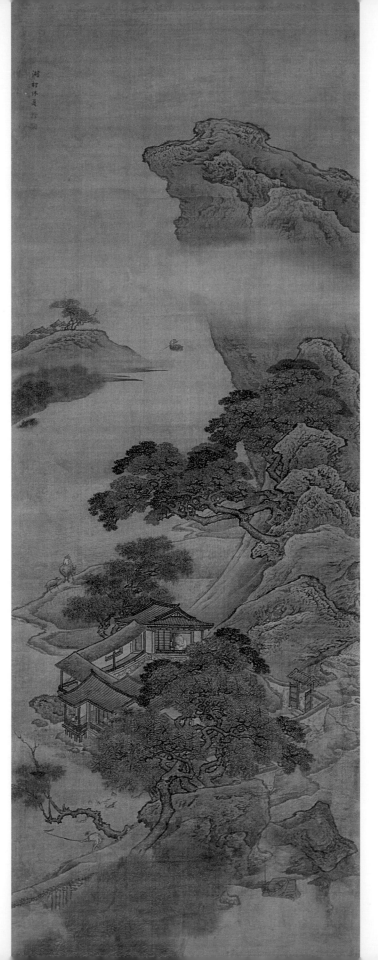

more were the artists' perceptions of famous historical buildings and gardens described in popular literature. Occasionally they also painted animals, birds, and flowers.

Summer Retreat at Lakeside Village depicts an idealized scene from a high vantage point outside the picture plane. A scholar reads leisurely in a room with blinds rolled up to let in breezes. The stillness reigning in his walled retreat is disturbed only by an occasional quack from the swimming ducks being driven to the shore by a villager on the other side of the building. The rural setting includes a boat moored beside a jutting rock in the foreground, a herding boy taking a water buffalo and its calf out to graze along the water's edge in the middle ground, and a fisherman heading back to this enclave in the far distance.

The carefully planned composition is interesting. The scholar's studio is located almost at its centre, protected by trees on three sides and backed by boulders and a flat-topped mountain. The weight of the looming mountain at the right, the animated contours of its boulders, and the devil's-face *cun* (modelling) strokes used to describe the texture of the rock surfaces combine to exude a vivid sense of restlessness. The overpowering image is counteracted by the expansive river course on the left half of the picture and by the mist drifting past the mountain top. Appearing to be oblivious to the contrasting natural environments and the various activities happening outside the house, the scholar sits calmly, engrossed in reading a book.

The brushwork is typical of the technical excellence of Yuan Yao's mature works. He moves with great ease using a variety of brush idioms that range from precise even lines for properly proportioned architecture, fluctuating lines for describing the rugged rocks, and soft sinuous lines for the portrayal of most other pictorial elements.

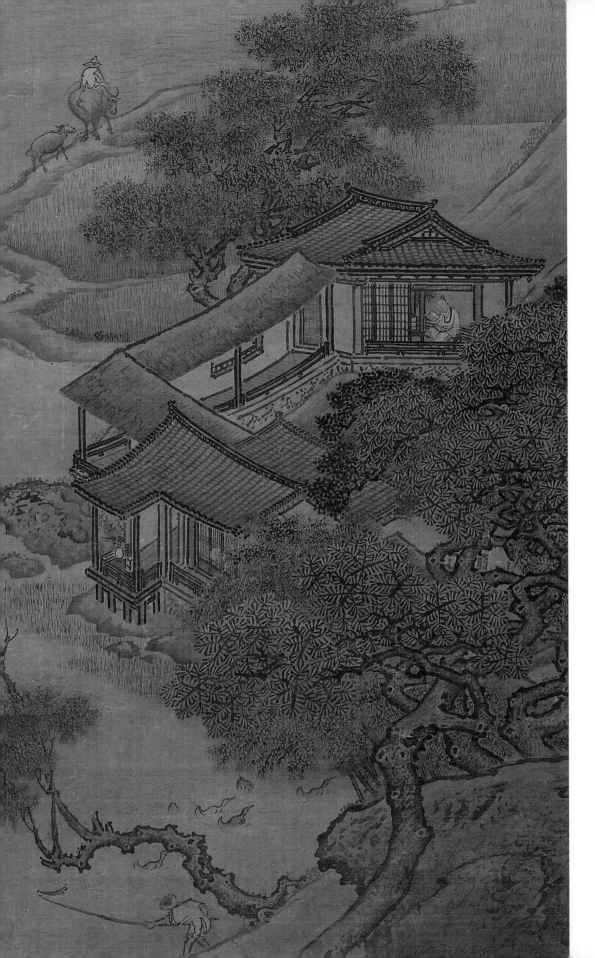

Curiously, this painting bears only a title and two seals of the painter. It does not have his signature. This phenomenon suggests that it likely belonged to a set of four paintings, each depicting a scene from one of the four seasons. Since the season featured in this work is summer, it would have been placed second in the set. This would explain the absence of the painter's signature because in normal practice an artist would sign only on the last painting (a winter scene) in a set.

Detail showing a scholar engrossed in reading in the studio of his summer retreat.

Qian Weicheng (1720–1772)
Complete View of the Lion Grove

Handscroll
Ink and colour on paper
Qing dynasty, ca. 1757
38.1 x 187.3 cm

University of Alberta Museums
Mactaggart Art Collection
2004.19.60
© University of Alberta Museums

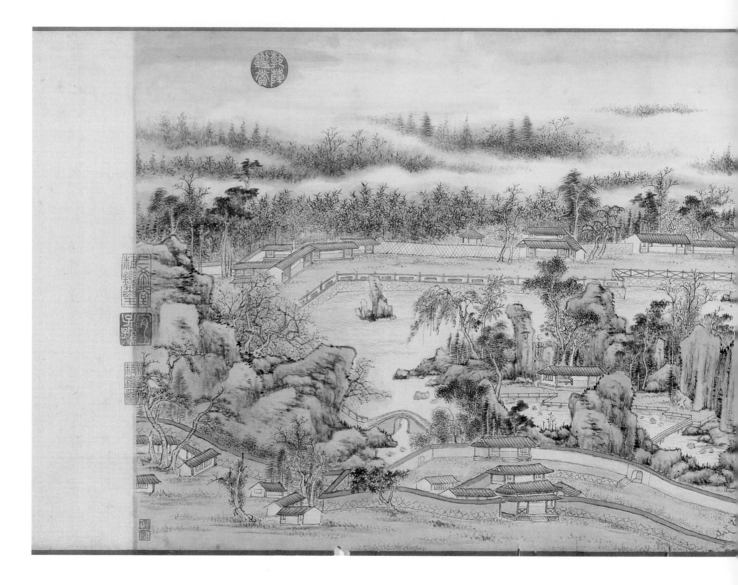

THIS PAINTING presents a panoramic view of the Shizilin (Lion Grove) Garden, located in the northeastern part of the city of Suzhou. It opens on the right (p. 26) with mists wreathing around scattered hills and tree groves with houses nestled among them. In the middle section, clusters of taller hills form natural barriers to shelter a strip of grassy plain below where a few cottages and pavilions are built in secluded spots. The view then changes to an open vista as the strip of land becomes an islet in a pond. The southern bank of this enclosed pond is linked to the islet by bridges. Both areas are clustered with rocks and trees. In the far distance, rows of trees emerge here and there from a thick veil of drifting mist, conjuring up a scene that echoes the beginning section of the scroll.

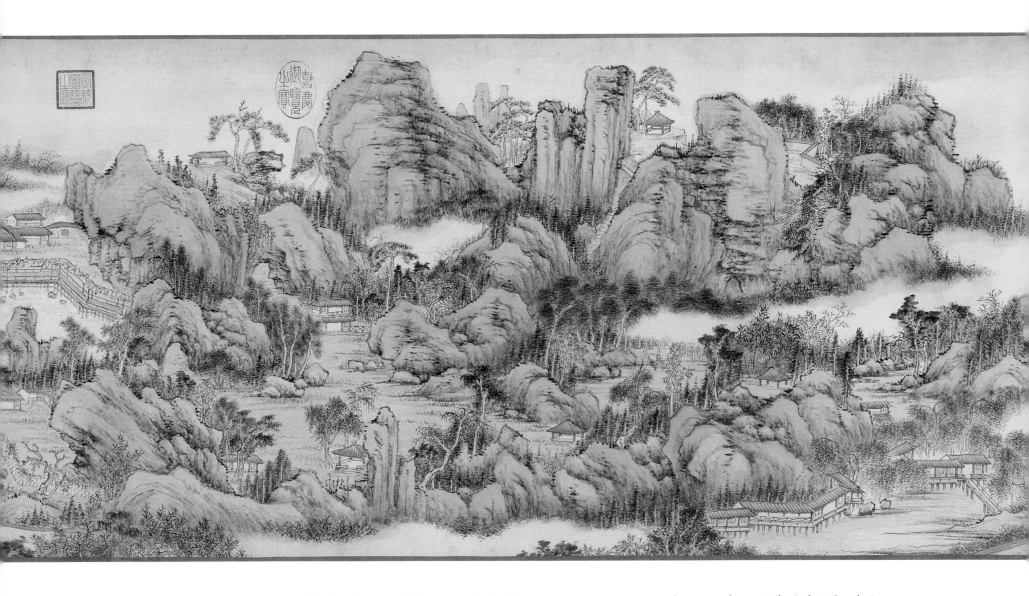

The Lion Grove was built in 1342 under the direction of Weize (also referred to as the Chan master Tianru, 1286–1354), a highly respected Chan Buddhist monk of the Linji sect during the latter half of the Yuan dynasty.[1] The site was previously owned by a Song-dynasty official.[2]

When Weize's disciples acquired the land, they inherited a property about 10 *mou* big, luxuriant bamboo groves, some twenty houses, and many Taihu (Lake Tai) rocks.[3] Chan Buddhists advocated meditation to achieve spontaneous enlightenment rather than the worship of images of the Buddha and his holy multitude to attain salvation. For this reason, Weize did not have any worship hall built on the site. Instead, his monks erected modest buildings in twelve scenic places enhancing them with Taihu rocks.

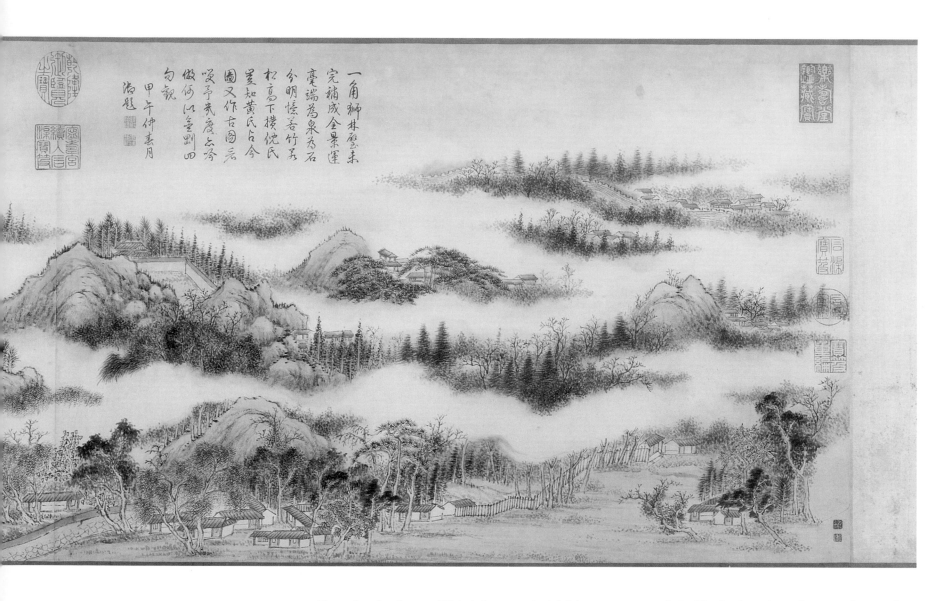

The enchanting views and Weize's fame as an insightful teacher attracted many intellectual patrons.

Initially, Lion Grove simply meant a Buddhist monastery of the Chan sect. In Buddhism, the lion is regarded as a guardian animal of the Law. It is often depicted singly or in pairs beside the image of a seated Buddha. In Chinese parlance a lion's seat (*shizi zuo*) originally indicated the seat of a Buddha, but later changed to mean the seat of a venerated monk as well. As for the word "grove (*lin*)," monasteries are often called *conglin* (also means tree grove) because their organization is akin to plants and vegetation that thrive in a systematic order in nature. In later times, as the fortune of the Lion Grove evolved, it became known more for its fantastically shaped Taihu

rocks.[4] Some of those added subsequently were intentionally fashioned after the images of lions in various poses to lure more visitors.

In 1363, the retired scholar-official, Zhu Derun (1294–1365), painted the Lion Grove at the request of Monk Ruhai, the third abbot in charge.[5] Ten years later, Ni Zan (1306–1374) and Zhao Yuan (ca. 1314/20–1376 /77) collaborated to produce another painting, also for Ruhai.[6] Since then, many more artists have painted the same subject.[7] They either recorded their impressions after visiting the garden or imitated the work by Ni and Zhao.

The celebrated work by Ni and Zhao eventually became part of the imperial painting collection during the Qing dynasty. The Qianlong emperor (r. 1736–1795) was so fascinated by the Lion Grove's long association with the elite that he visited this fabled place no less than five times between 1757 and 1784, each time when he undertook a southern inspection tour.[8] On his first visit he even sent dispatchers to Beijing to fetch the painting by Ni and Zhao so he could compare the pictorial content with the real scenery. On this and subsequent visits he composed poems about various aspects of the garden, penned name plaques for certain scenic spots, and copied the scroll by Ni and Zhao three times. More amazing, after his third visit in 1765 he gave orders to replicate the Lion Grove in both the imperial garden called the Changchun yuan (Garden of Eternal Spring) and his summer palace in the northeastern city of Chengde. In addition to his emulation of the Yuan scroll, he also commissioned various painters to do the same or to paint the Lion Grove or its simulated version *in situ*.[9]

Qian Weicheng, the painter of *Complete View of the Lion Grove*, was a high official who had served in the Board of Works and Board of Punishments. As a noted calligrapher and painter of landscape and plant life, he also produced calligraphy and paintings for the enjoyment of the Qianlong emperor.[10] According to the colophon he wrote at the end of the scroll, he was among the entourage when the emperor first visited the Lion Grove in the spring of 1757. Prior to this visit, the emperor had granted him an opportunity to view the work by Ni Zan and Zhao Yuan, no doubt having Qian Weicheng in mind to make a visual record of the garden later. Although the exact date of Qian Weicheng's work is uncertain, most likely it was done in the same year or shortly after since the emperor would have been impatient to wait for a long time to see the result of Qian's observation.

Qian also describes in detail the layout of the garden and the wonderful features of the artificial groupings of fantastic rocks. Yet, as he points out, unlike Ni Zan (and Zhao Yuan) who painted only a certain area of the garden, what he did was to record a general view of it. By doing so, was he trying to avoid his work being compared with the Yuan work which everybody (in particular the Qianlong emperor) who had seen it highly esteemed? Or, was it because he would rather approach the subject from a different perspective since by that time the Lion Grove had become quite different from four centuries previous when it was purely a Chan Buddhist retreat? In any case, although Qian's painting may be viewed as an eighteenth-century visual record of the Lion Grove, it is not inconceivable that he has also exercised artist's licence to a certain degree in order to create a work that would meet the Qianlong emperor's aesthetic taste, a taste that demanded careful brushwork, naturalistic images, well-balanced composition, and visual harmony.

As evidenced in this work, Qian Weicheng uses soft outlines to delineate all pictorial elements. Even the modelling strokes for describing the rough texture of the rock surfaces and the crevices of the hills are executed in

diluted ink. The colours are predominantly subdued tones of ochre and green, applied evenly to the earth forms and the grassy plain. The gentle brushwork and the uniform colour distribution imbue the painting with a refined look and a sense of stability and tranquillity. This otherwise prosaic scene, however, is enlivened by the varied foliage of assorted trees rendered in darker shades of green, ink stipples suggesting mossy vegetation on some of the rock surfaces, and belts of flowing mist. All of these not only evoke a sense of the moist atmosphere and luxuriant plant growth common to the Jiangnan region where Suzhou is situated, but also serve as effective artistic devices to unify other pictorial elements.

Qian Weicheng's brush manner is reminiscent of Ni Zan and Huang Gongwang (1269–1354), Yuan-dynasty masters whom literati painters of all subsequent periods venerated for their ability to capture the essence of nature through relaxed and uncontrived brushwork. This stylistic preference was also embraced by many distinguished bureaucrats of the Qing dynasty in their artistic pursuits. In fact, as revealed by art historians, Qian Weicheng's painting style was much influenced by Dong Bangda (1699–1769), a senior official whom he befriended.[11] Dong was an indefatigable follower of the Four Yuan Masters– Huang Gongwang, Wu Zhen (1280–1354), Ni Zan, and Wang Meng (1298–1385).[12] Another painter who had exerted stylistic influence over Qian Weicheng was Wang Yuanqi (1642–1715), one of the four early Qing orthodox masters who also took the Four Yuan Masters as models.[13] Since Qian Weicheng was firmly rooted in the lineage of the Yuan literati painters, perhaps out of respect for Ni Zan's habit of painting landscapes devoid of human presence, he also did not depict any human activity in this scroll. The only signs of human presence are the neatly designed architectures sprinkled throughout the scenery and the well-tended trees and plants. Somehow this rather strange feature instills an idealized, dream-like quality.

Huang Dao, Men Yingzhao, and Jiang Renshu (act. 1736–1795)
Drawings of Costume and Accessories of the Empress Dowager and Empress

34 folios
Ink and colour on silk, mounted on boards
Qing dynasty, 1759
42.3 x 40.8 cm (each leaf)

University of Alberta Museums
Mactaggart Art Collection
2004.19.1.1–68
© University of Alberta Museums

p. 30: Formal summer court robe for the empress dowager and the empress, first style.

p. 31: Formal summer court robe for the empress dowager and the empress, second style.

A CENTURY or so after the establishment of the Qing dynasty, the Qianlong emperor instigated various measures to standardize important rituals and objects used for their observance.[1] These initiatives, he felt, were necessary to strengthen the control of the central government over its subjects and to safeguard an orderly society.

One initiative was the compilation of the *Huangchao liqi tushi* (A Collection of Drawings of Ceremonial Paraphernalia of the Qing Dynasty). Prince Zhuang (Yunlu, 1695–1767) was appointed director of the project, with the assistance of five high officials, namely, Jiang Pu (1708–1761) from the Board of Revenue, Wang Youdun (1692–1758) from the Board of Civil Office, Guanbao from the Board of War, Sanhe from the Board of Works, and He Guozong from the Board of Rites.[2] Under them was a team of archivists, compilers, copyists, and illustrators. Notably, Huang Dao, Men Yingzhao, and Jiang Renshu were responsible for drawing the images and transcribing the texts.[3]

Completed in 1759, the collection had a total of 1,300 illustrations of objects used for various official ceremonies by the emperor and his consorts, members of the imperial household, government officials of all ranks, as well as their spouses.[4] These were divided into six categories, namely, ritual vessels, scientific instruments, costume and accessories, musical instruments, state regalia, and arms and armour.

Four years later, more drawings were produced to supplement the original set, this time under the direction of Fulong'an (1743 or 1746–1784).[5] A printed version based on this expanded set illustrated objects in plain line drawings. It was produced in 1766 by the printing house set up in the Wuying dian (Hall of Military Prowess).[6] The six Boards used it as a reference tool for compliance with state regulations. It ensured that officials and the populace did not commit the grave crime of using any article which was inappropriate to their social status.[7]

The original hand-drawn version was kept in the summer palace, the Yuanming yuan (Garden of Perfect Brightness), for the enjoyment of the Qianlong emperor.[8] Part of it was removed by the joint forces of Great Britain and France during the Second Opium War in 1860. While some drawings are currently housed in the Palace Museum in Beijing, many have been dispersed to other parts of the world.[9]

The present group of drawings was previously owned by Sir Thomas Phillipps (1792–1872) and Philip Robinson (1902–1991).[10] It is kept in a portfolio bearing a gilded English title, *Costume of the Court of the Chinese Emperor Ch'ien Lung, The Original Paintings from the Summer Palace, Pekin, 18th century*—likely made during Phillipps's possession. There are altogether 34 folios, each made up of two joined leaves. They depict summer and winter costume and

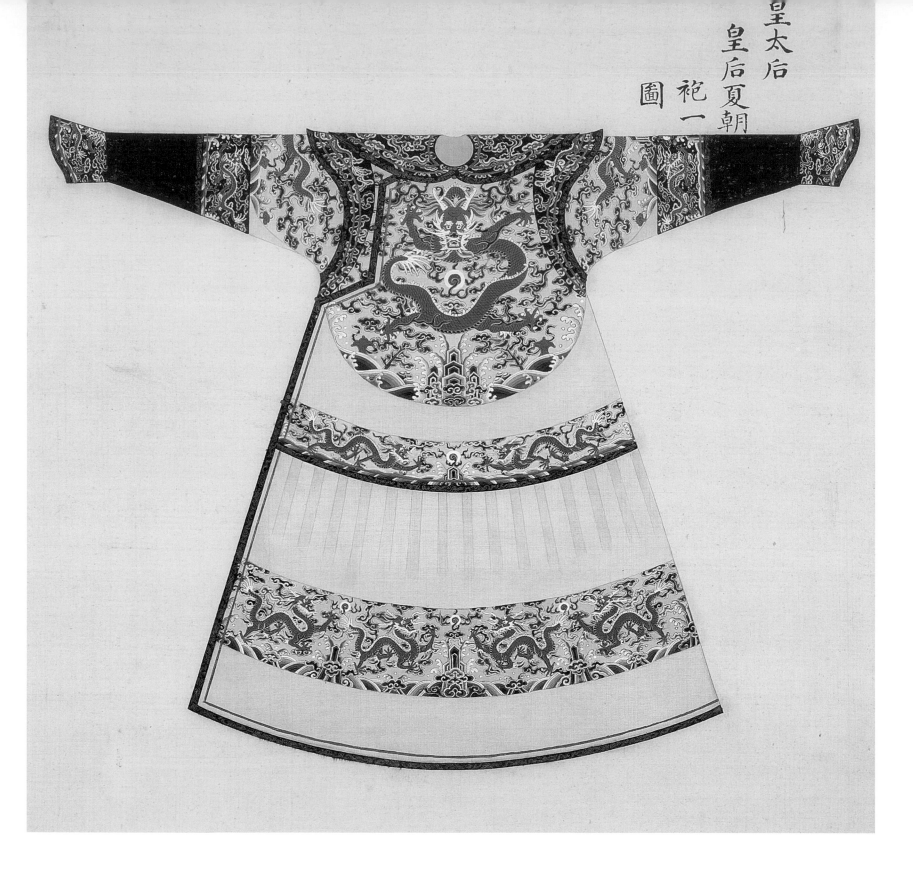

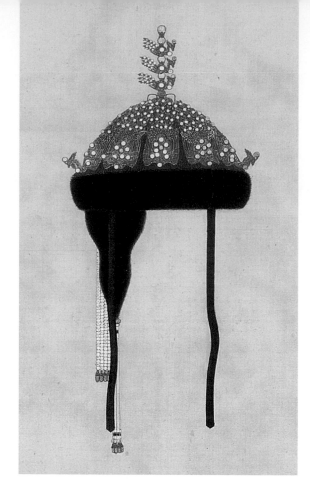

accessories appropriate to an empress dowager or an empress.[11] These articles include court robes (*chaopao*), court vests (*chaogua*), underskirts (*chaoqun*), court head-dresses (*chaoguan*), ceremonial kerchieves (*caiyue*), torque-like collars (*lingyue*), court necklaces (*chaozhu*), and earrings (*ershi*). Typically, an article is illustrated on the right-hand side of a folio together with a caption iden-tifying its function and the user. Rules and regulations pertaining to its design and materials used for fabrication are written in large and clear *kaishu* (standard script) on the left-hand side. When both sides are used for the illustra-tion of the front and back of a garment or a headdress, the instructions are provided on a separate folio kept next to the relevant drawings.

All articles of clothing and adornment are drawn in reduced scale based on real objects. Their exquisite images and correct representation testify to the skillful drafts-manship of the illustrators and the meticulous attention they gave to form, proportion, colour, and decoration. In modern days, these fine drawings still have an educational function. Instead of serving as exemplars to assert power or warn people of transgressions, they now give us a clear idea of the magnificent formal wardrobes of the empress dowager and the empress, and are invaluable for extensive research in Chinese textiles, costume, and design.

The only recorded painter among the three men was Men Yingzhao, who was a member of the Chinese Bordered Yellow Banner. Scanty information about him reveals that he held the lowest literary degree, *jian-sheng* (Student of the Imperial Academy). He worked as a draftsman at the Maoqin dian (Hall of Diligence) in the Imperial Palace, as an Assistant Officer of Instruction in the painting section of the Siku guan (an office in charge of the compilation of the *Siku quanshu* or *The Complete Library of Four Categories of Written Records*), as an Eighth-rank Official Writer in-waiting, and was later promoted from a Second-class Secretary in-waiting to a Senior Secretary at the Board of Works. He eventually obtained an appointment as Prefect of Ningguo fu, located in the southeastern part of Anhui province.

As a painter, Men Yingzhao is noted for specializing in figures, portraiture, flowers, and architecture. It is likely that during his tenure at the Siku guan he became involved with the painted and the printed versions of the *Huangchao liqi tushi*.[12] Besides participating in these two huge projects, he also painted, at the command of the Qianlong emperor, 91 scenes to augment Xiao Yuncong's (1596–1673) three albums that illustrated the *Lisao* (Encountering Sorrow), a famous epic written by Qu Yuan (340–278 B.C.), the Warring States poet from the State of Chu. Notwithstanding our knowledge of this painter, there is no way to distinguish which folios are from his hand because none of the drawings are signed.

Xu Yang (act. ca. 1750–after 1776)
The Qianlong Emperor's Southern Inspection Tour No. 2: Crossing the Grand Canal at Dezhou[1]

Handscroll

Ink and colour on silk

Qing dynasty, 1764–1770

68.9 x 1690.3 cm

University of Alberta Museums

Mactaggart Art Collection

2004.19.15.1

© University of Alberta Museums

pp. 34–35: Inhabitants of the city of Dezhou in a state of last-minute preparation for the royal visit (detail).

THE QIANLONG EMPEROR (r. 1736–1795) emulated his grandfather, the Kangxi emperor (r. 1662–1722). The Kangxi emperor had embarked on six inspection tours to southern China. Between 1751 and 1784, the Qianlong emperor did the same.[2] He also visited more or less the same places, including Jiangning, Suzhou, Yangzhou, Hangzhou, Haining, and Jiaxing, all located near the Grand Canal in the lower Yangzi River delta. Both monarchs had serious missions to accomplish on these trips.

In the case of the Qianlong emperor, his activities included supervising water control, conducting military reviews, examining the performance of local officials, paying tribute to venerated Chinese monuments, and receiving the gentry and the intellectuals. His purposes were threefold: to ensure and assert the government's military prowess, to show the inhabitants of the Jiangnan region the government's concern about their livelihood and wellbeing, and to impress upon the intelligentsia that the government valued their support. All these activities were subtle tactics for maintaining prosperity and stability in this wealthiest region, so vital to the political and economic soundness of China.

In 1691, the Kangxi emperor commissioned a pictorial record of his second tour. A set of twelve monumental scrolls was completed by 1708.[3] Similarly, the Qianlong emperor desired visual documentation of one of his southern inspection tours. The one depicted was his first tour of 1751. Following its precedent, this set also consisted of twelve monumental scrolls, each recording a section of the journey. Both sets, however, were dispersed during the end of the Qing dynasty.[4]

The present scroll, no. 2 in the set, depicts the second leg of the journey which took place in the first month of the year. After leaving Beijing the royal procession followed the south-running course of the Grand Canal. The scene featured here shows the travellers about to enter the city of Dezhou, located at the northwestern border of Shandong province. As the tour would take several months, the imperial retinue consisted of a large number of people. They included members of the royal household, attendants, servants, guards, as well as senior members of the Grand Council and the Six Boards.[5]

In this extremely long handscroll, the procession is not depicted as one body. Rather, it is broken up into groupings of varied sizes. The most prominent grouping is naturally comprised of the emperor and his entourage. They are seen approximately one third into the whole length of the scroll, crossing the canal on an expedient floating bridge. The emperor is shown riding in a palanquin carried by a team of bearers. They are preceded by an equestrian honour guard and followed by bodyguards on horseback. Witnessing the pomp are crowds of local officials and inhabitants. They kneel on the banks on

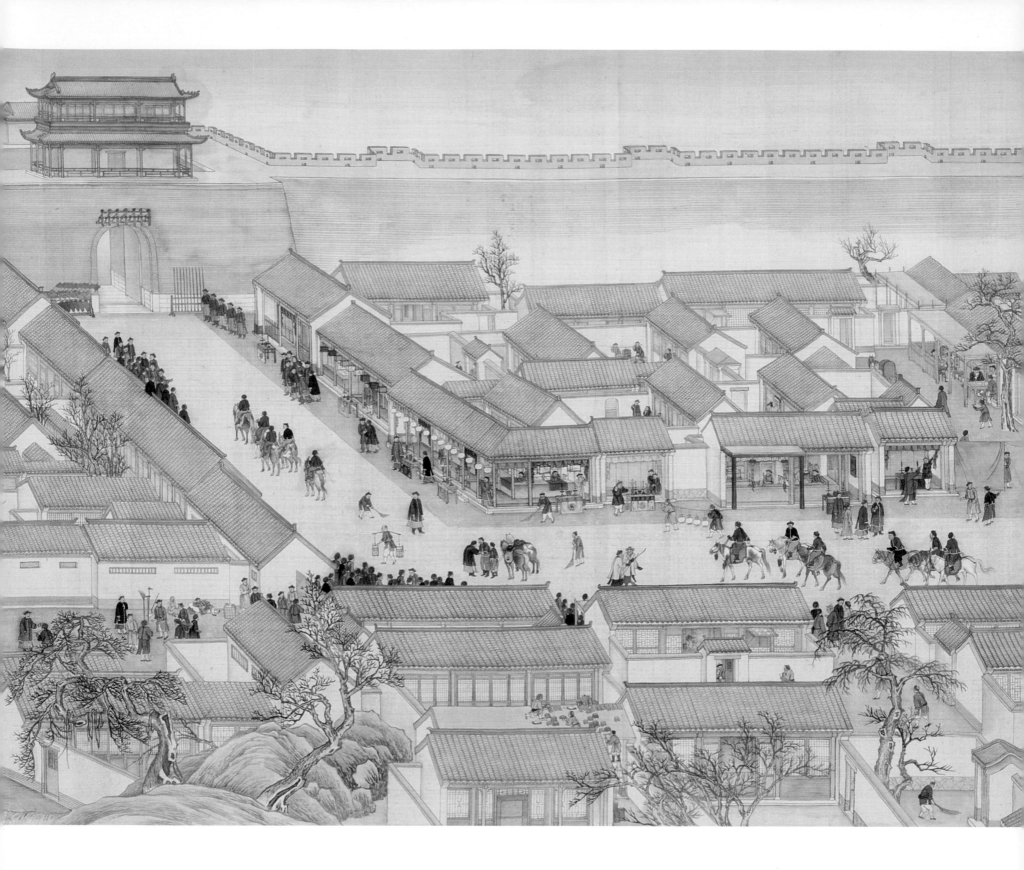

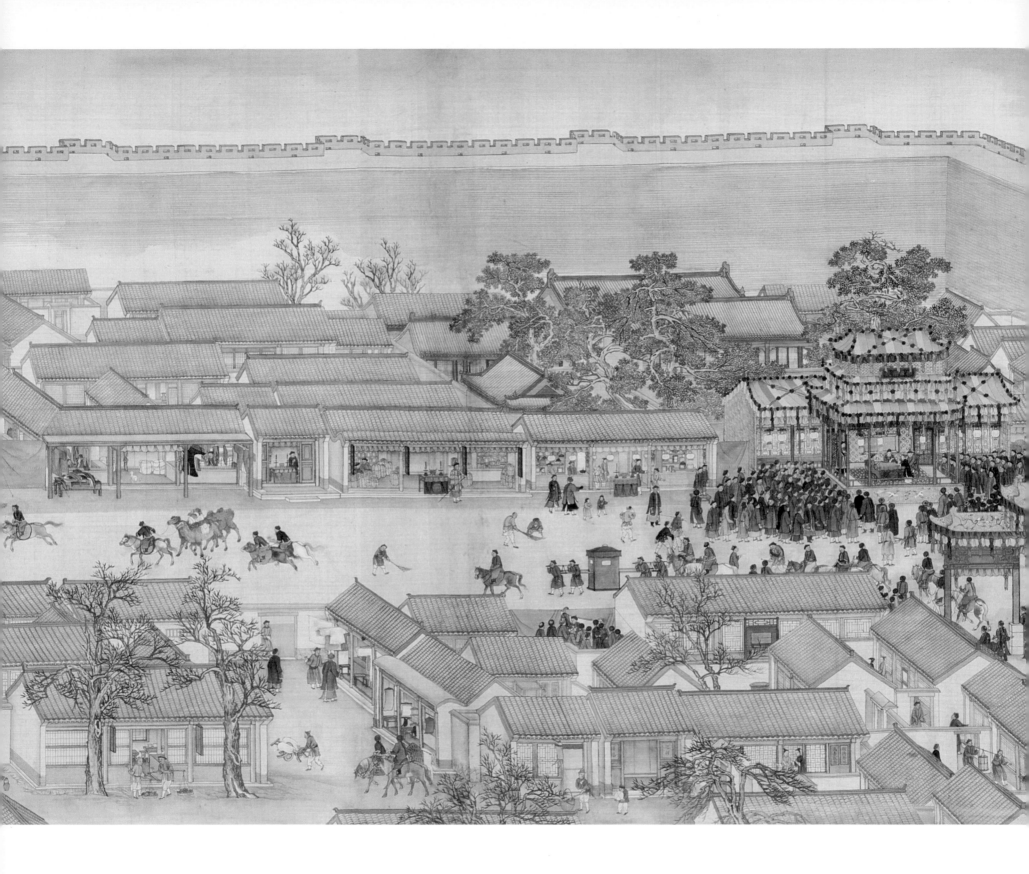

both sides of the canal, some knocking their heads on the ground to signal respect. The remainder of the royal retinue follow closely and congregate on a road not far behind. They wait for the emperor to reach the other side of the canal before they make their move. Others, who seem to be in no hurry, can be seen in twos and threes some distance away, chatting or observing the surroundings while their horses walk leisurely. Since the painting begins with these tardy travellers, they lead the viewer through a bleak countryside to the scene of climax where there is a greater sense of action and animated colours (provided by the royal regalia and the festooned arches).

As the painting progresses, more officials and inhabitants kneel along the way ready to welcome the imminent arrival of the emperor. The countryside then changes to the walled city of Dezhou, which furnishes another focal point of interest. The city is in a state of last-minute preparation for the royal visit. Its main street is alive with colourfully decorated architecture. Shops on both sides have rows of lanterns attached to their eaves to brighten the facade. Some also put out covered tables with vessels holding incense and candles to create a sense of festivity. While the inhabitants try to go about their daily business in a normal way, officers belonging to the imperial retinue are seen arriving ahead of the emperor to inspect the street for security and cleanliness.

In the last section, the city scene changes back into the countryside. In a small village people bring bundles of hay and bales of grain to a government granary. The huge haystacks lying around indicate a good year. In the midst of this rural scene, mounted imperial officers can be seen trickling down a distant bank, close at the heels of a team of retainers in charge of horse-drawn carts and camels laden with provisions and luggage. These are the people

who travel well ahead, to pave the way for the emperor's smooth journey.

The painter, Xu Yang, spent six years to finish the whole set, from 1764 to 1769. In 1771, he was again commissioned to paint a second set on paper.[6] This time it took him four years to complete. Interestingly, Xu Yang's appointment as a court painter was related to this very first southern inspection tour. During the emperor's visit to Suzhou, Xu, who was a native of that famous city, seized this rare opportunity to present his paintings for imperial approval. The Qianlong emperor was suitably impressed by his painting skill and he was recruited. He won imperial favour instantly. According to a record in the imperial archive, when Xu arrived in Beijing in the sixth month of 1751, he was allowed to receive a stipend of eleven taels of silver a month, the same amount as two other well-known court painters, Yu Sheng (1692–1767) and Ding Guanpeng (act. ca. 1738–1768), were receiving.[7] During his twenty-six-year tenure Xu Yang produced many works for imperial enjoyment. Their subjects encompassed landscape, figure, and flower. The Qianlong emperor's unfaltered admiration of Xu's worthy performance is also reflected by the fact that the beneficent patron bestowed upon him the title of *neige zhongshu* (Secretary of the Grand Secretariat), to fulfill his dream of becoming a government official.[8]

Since Xu Yang did not become a court painter until mid-1751, he did not participate in the first southern inspection tour. The knowledge he needed for painting this set was probably based on written records and his personal observation, obtained during the second, or the third tour conducted in 1757 and 1762 respectively.

In this painting, Xu Yang shows his versatility in many respects. The composition, for instance, is constructed with many horizontal elements (low hills and flatland

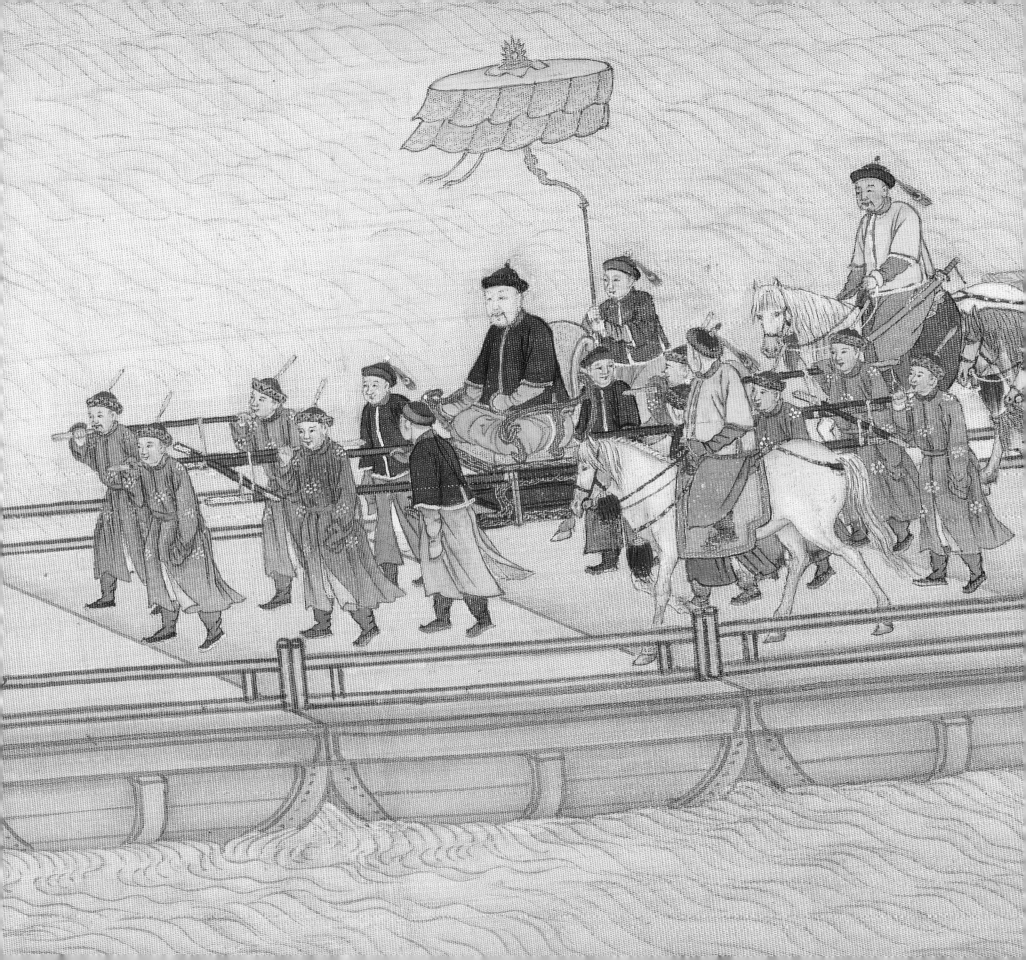

in the background in addition to the royal procession's basically horizontal movement from the right to the left) that correspond with the painting format. Yet, within this preponderant horizontal scheme are integrated pictorial elements depicted with curves (e.g., waves, the winding road that leads to the city of Dezhou, and certain parts of the canal embankment), verticals (trees and architectural supports), and diagonals (tiled roofs, city walls, and leaning trees) to induce a sense of visual diversity.

Xu Yang also demonstrates his impeccable draftsmanship, attention to detail (he includes imperial guards urging dallying officials to move on faster), and sense of humour (for example, he portrays in one detail two curious villagers hiding behind houses taking a peep at the royal pomp through a thatched wall and in another detail seen within the city of Dezhou a street peddler who, on finding the junction of a side street to the main street is blocked by expectant onlookers, prefers to relax against a building wall).

What stands out conspicuously in this work is his attempt at synthesizing traditional Chinese painting techniques with Western painting concepts. The faces of the figures, the execution of the rock surfaces, and the utilization of flowing mist as a transitional device at the juncture of two different scenes (such as when the rural scene changes to the walled city of Dezhou) are all typical methods employed by Chinese painters. The linear perspective, diminutive scale consistent with distance, and the anatomically correct figures, however, reflect the influence by the Jesuit painters serving the imperial court at the time, such as Giuseppe Castiglione (1688–1766), Ignace Sickelpart (1708–1780), and others.

Giuseppe Castiglione (1688–1766)
Ignace Sickelpart (1708–1780)
Jean-Denis Attiret (1702–1768)
Jean Damascene (d. 1781)
**Conquest of the Western
Frontier of China**

Portfolio set
Ink on paper
Qing dynasty, 1764–1774
52 x 90.5 cm (each image)

University of Alberta Museums
Mactaggart Art Collection
2004.19.68.1.1–36
© University of Alberta Museums

THE DZUNGARS, a West Mongolian tribe, became a powerful force during the last quarter of the seventeenth century. They caused political unrest in Eastern Turkestan and even threatened the security of China. The Kangxi emperor (r. 1662–1722) personally commanded three campaigns to quell these potential invaders. The Yongzheng emperor (r. 1723–1735) also tried to wipe them out, but his troops were defeated. At the beginning of the Qianlong period (1736–1795) a treaty designating the Altai Mountains as the boundary between China and Dzungaria was signed with the Dzungars and tension was somewhat softened.

In 1745, the Dzungar leader, Galdan Tseren, passed away. His demise sparked off a series of internal power struggles, which weakened the Dzungars' strength. Seizing this opportune moment, the Qianlong emperor sent troops to Dzungaria in 1755 and 1756. They successfully crushed these longstanding enemies.

When the Dzungars held sway, they forced the Muslims into vassalage, holding as hostages their spiritual and political leaders, the two brothers, Burkhan-al-Din and Khozi Khan, as well as the Muslim nobility. In 1755, when the Qing expedition stormed the Ili Valley, the hostages were released. But, on finding themselves under the control of yet another overlord, the two brothers joined forces to defy the Qing authority. In 1758, a Chinese envoy sent to Kucha was murdered by Khozi Khan. This act enraged the Qianlong emperor who immediately ordered

a punitive expedition. Both sides fought fiercely. In the summer of 1759, the battles came to an end when the two brothers were finally rounded up in Badakshan and killed.[1]

In less than five years, the Chinese conquests of the Dzungars and the Muslims brought to the empire: Eastern Turkestan, the Tarim Basin, and the region of seven river valleys between the Ili and Karatal, and as far as Lake Balkhash. This vast area was named Xinjiang (New Dominion). The overjoyed Qianlong emperor immediately initiated a series of celebratory activities: he held an official ceremony at the Meridian Gate to mark the victories; he left the palace to greet the returning triumphant soldiers in the outskirts of Beijing; and he honoured the officers with a sumptuous banquet within the palace precincts.

In addition to the pompous fanfare, details about the conquests were carefully collected and documented in writing and visual forms. These included engraving the two hundred or so war poems the emperor had composed on stone stelae to be deposited in the Wucheng Dian (Hall of Military Achievements) and writing and engraving a full record of the conquests on stone stelae to be housed in the Imperial Academy of Learning. As visual deterrents against further attempts at incursion, individual accounts of major battles were also engraved on stone stelae and installed at strategic sites in Eastern Turkestan.[2]

On the pictorial side, fighting scenes at battlefields as well as portraits of meritorious officials were produced. These were displayed in the Ziguang Ge (Hall of Purple Light), an edifice on the palace ground that commemorated military exploits.

The technique of copperplate engraving was introduced to China by the Italian Jesuit Matteo Ripa (Ma Guoxian, 1682–1754). In 1713, at the behest of the Kangxi emperor, Matteo Ripa supervised the production of a set of 36 views of the imperial summer palace in Chengde. The success of this set and the good impression the Qianlong emperor had of a German engraving depicting a war scene made him decide to also record the conquests of the Dzungars and the Muslims in this medium. In 1762, Giuseppe Castiglione (Lang Shining), Ignace Sickelpart (Ai Qimeng), Jean-Denis Attiret (Wang Zhicheng), and Jean Damascene (An Deyi) received an order to design 16 small sketches. Their final drawings, completed in 1764, were sent in four installments to Paris between 1765 and 1766 where engravings were executed under the direction of Charles-Nicolas Cochin (1715–1790) of the Royal Painting Academy at the court of Louis XVI. The engravers involved in this project included: J. PH. Le Bas (1707–1783), Augustin de Saint-Aubin (1736–1807), B. L. Prévot, Jacques Aliamet (1728–1788), Louis-Joseph Masquelier (1741–1811), Denis Née (1732–1818), Pierre-Philippe Choffard (1730–1809), and N. De Launay (1739–1792).[3]

The engraving and printing demanded the highest quality of workmanship. The paper used for printing also had to be specially manufactured. Two hundred copies of each engraving were printed. This huge task took time. Finally, the finished products and the copperplates were shipped back to China, also by installments, between 1770 and 1774.

On various occasions, the Qianlong emperor bestowed the sets of 16 engravings to princes and high officials. By 1784 the stock ran out. As a result, another 200 sets were printed by the imperial workshops. Their quality was understandably inferior. For display or for preservation, they were distributed to imperial travel lodges and monasteries throughout China.[4]

As exemplified by the Mactaggart set, a complete set would have consisted of 16 engravings and 16 additional sheets each inscribed with one or several annotated poems by the Qianlong emperor describing the content of the illustrated scene. Presumably, each text would have been placed after its relevant engraving. The whole group would have been preceded by an additional sheet with a preface also written by the emperor and followed by a postscript on another separate sheet, which recounted the history of the conquests and their documentation in various media. The postscript was jointly written by Fu Heng (d. 1769), Yin Jishan (1696–1771), Liu Tongxun (1700–1773), Aligun (d. 1769), Shuhede (1711–1777), and Yu Minzhong (1714–1780), all high officials.[5] These explanatory texts are printed by means of engraved woodblocks.

The last sheet of this set is an additional colophon. It is hand-written by the recipient Gioro Tuside (d. 1779), a Manchu who held the titles of President of the Board of War and Governor-General of the provinces of Hunan and Hubei.[6] It is dated the seventh month of 1779, shortly before his demise. In the colophon, he indicates clearly that he did not participate in the conquests, but was pleased that his descendants would learn much from these valuable engravings. Apparently his wish was indeed respected by his progeny. A brief acknowledgment of viewing this set by his great grandson, Bingcheng, can be seen inscribed discreetly along the left-hand border,

following his signature. Written on the 12th day of the 4th month in 1843, it shows that sixty-four years later the set was still carefully kept in the family.

The engravings are all designed with a panoramic view filled with abundant realistically rendered details. Characterized by intense action and drama, the battle scenes portray the brutal fighting between the pursuers and the pursued, the dead, the wounded, and the horror-stricken runaways. A modern viewer would find it easy to be transported back in time and space to the rugged battlefields to relive the horror and excitement that happened more than two hundred years ago. By contrast, the scenes that depict ceremonies marking the surrender of the defeated, presentation of captives, and the home-coming of the victorious troops emphasize joy, order, and dignity. Also worthy of note are the Western painting techniques that emphasize the representation of pictorial elements in anatomically correct proportions, the use of a single light source and a fixed vantage point, and the creation of a three-dimensional perspective.

The set of engravings illustrating the pacification of the Dzungars and Muslims was considered a great success at the time of its production. Subsequently, seven more sets of engravings were created to commemorate other campaigns conducted in the west, southwest, and south-east of China.[7] These were designed by Qing court painters and printed by the imperial workshops. Their artistic quality is far from the very first set which served as their model. Notwithstanding this defect, all sets of engravings were created for multiple purposes: as visual records documenting important military campaigns, as propagandistic materials to announce the achievement and glory of the Qing government, as decoration in government institutions and public places, as esteemed gifts for worthy recipients, and as subtle warnings to those who dared to contemplate undermining the Qing authority.

Portfolio Set (16 copperplate engravings)

1. *Accepting the Surrender of the Inhabitants of Ili after Its Defeat*, from a drawing by Ignace Sickelpart.
2. *Storming of the Camp at Gädän-Ola*, from a drawing by Giuseppe Castiglione.
3. *The Battle of Oroï-Jalatu*, artist unknown.
4. *The Battle of Kulonggui*, from a drawing by Jean Damascene.
5. *The Victory at Khorgos*, from a drawing by Jean-Denis Attiret.
6. *The Chieftain of Ush Surrenders with His City*, from a drawing by Jean Damascene.
7. *The Battle of Tonguzluq*, from a drawing by Giuseppe Castiglione.
8. *Raising the Siege of the Black River*, from a drawing by Giuseppe Castiglione.
9. *The Grand Victory of Qurman*, from a drawing by Jean Damascene.
10. *The Battle of Arcul*, from a drawing by Jean-Denis Attiret.
11. *The Battle of Yesil-Kol-Nor*, from a drawing by Jean Damascene.
12. *The Battle of Qos-Qulaq*, from a drawing by Jean Damascene.
13. *The Khan of Badakshan Offers Indemnity*, from a drawing by Jean Damascene.
14. *Presenting the Prisoners Taken during the Pacification of the Muslim Tribes to the Emperor*, from a drawing by Jean-Denis Attiret.
15. *The Emperor Goes to the Suburb to Welcome Back the Victorious Troops after the Conquest of the Muslim Tribes*, from a drawing by Jean Damascene.
16. *The Emperor Gives a Victory Banquet in Honour of the Meritorious Officers and Soldiers*, from a drawing by Giuseppe Castiglione.[8]

Storming of the Camp at Gädän-Ola, *from a drawing by Giuseppe Castiglione.*

Luo Ping (1733–1799)
Flowers, Birds, Fish, and Rabbit

Album of 10 leaves
Ink on paper
Qing dynasty, dated 1781
32.4 x 33.2 cm (each leaf)

University of Alberta Museums
Mactaggart Art Collection
2004.19.73.1.1–10
© University of Alberta Museums

Right: Leaf no. 1, Peony
p. 45: Leaf no. 6, Grapes

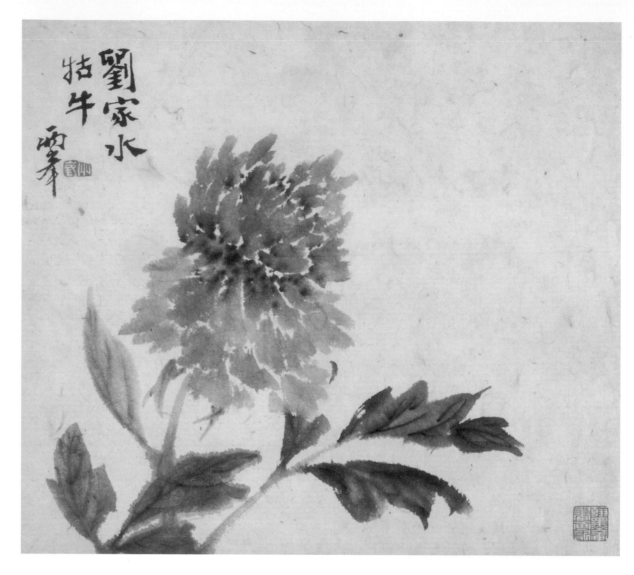

1 **Peony**

 A water buffalo belonging to the Liu family.

 —*[Painted by] Liangfeng*

2 **Swallow on a Willow Branch**

 —*[Painted by] Liangfeng*

3 **Three Chicks**

 Chirp, chirp, chirp, chirp…
 [The chicks] look for food among the grass by the east wall.
 [They are] waiting for their feathers to grow,

[By then] one single crow will let the whole world know that
 dawn has arrived.

 —*[Painted by] Liangfeng*

4 **Lotus**

 [As if wearing] waterdrop pendants and windswept skirts.

 —*[Painted by] Liangfeng*

5 **Fish**

 —*[Painted by] Liangfeng*

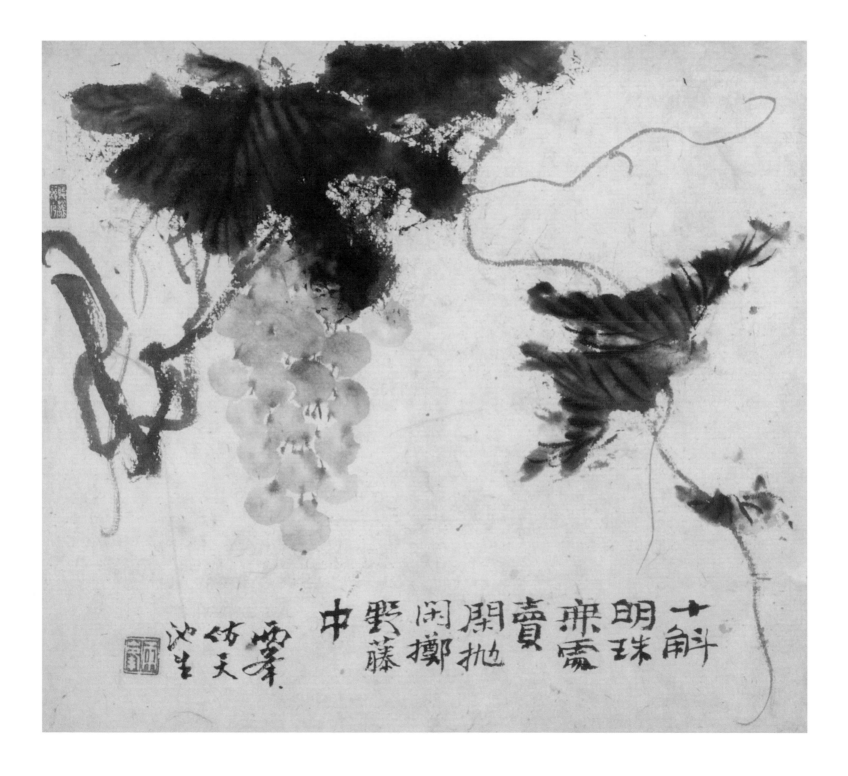

Leaf no. 9, Rabbit

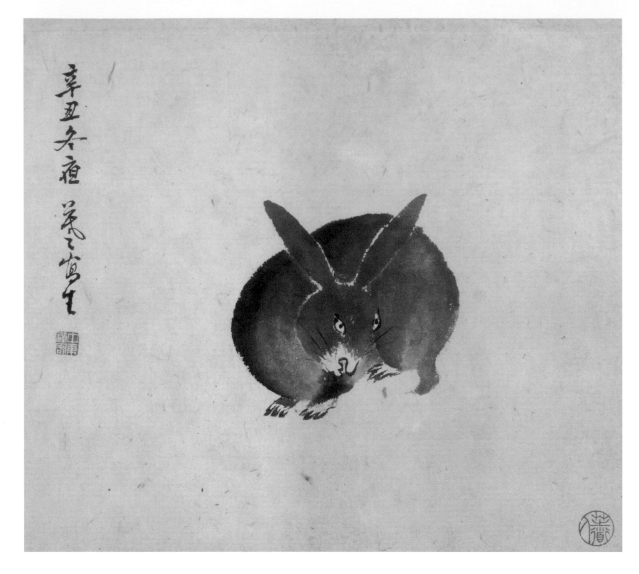

6 **Grapes**

[Similar to] ten bushels of unsaleable pearls,

They are thrown carelessly among the wildly entangled vines.

—[Painted by] Liangfeng in the manner of

[the brushwork of] Tianchisheng.[1]

7 **Tuberose**

While bending [my] head to pluck a tuberose,

[My] jade hairpin fell [to the ground].

—This is a poem composed by a woman in Puzhou.

No other poem eulogizing this flower can rival this one.

Inscribed by Luo Ping, [alias] Liangfeng daoren.

8 **Banana Trees**

The autumn wind summons back old dreams.

The splattering night rain [inspires] new poems.

—[signature undecipherable]

9 **Rabbit**

—Painted from life by [signature undecipherable]

on a winter night of the year xinchou *(1781).*

10 **Narcissi**

[By] the tributary of the Luo River,

The goddess walked nimbly in her silken socks.

—Liangfeng [painted this] as a gift for Chunbo.

LUO PING was born in Yangzhou in Jiangsu province. His family's roots, however, were in Shexian in Anhui province. During his life he adopted many fancy names that reflected different events and moods. Among them Liangfeng (Two Peaks) was the most frequently used.[2] His father, Luo Zhi, painted landscapes and apparently was acquainted with Zheng Xie (1693–1765), one of the Eight Eccentric Painters of Yangzhou.[3] Unfortunately, Luo Zhi died when Luo Ping was still an infant. The little boy was raised by his uncle, Luo Su, a local official and a collector of ink rubbings of bronze and stone inscriptions.

Through the intricate relationships between his uncle and eminent scholars and patrons in Yangzhou, Luo Ping's literary talent became known to Jin Nong (1687–1763). Jin Nong was a respected poet, calligrapher, and painter. From 1756 onward, Jin Nong took Luo Ping under his wing by teaching him poetry and painting techniques. Luo Ping was a bright pupil. He developed his painting skills so quickly that soon after he started his studies under Jin Nong he was already ghost-painting for the master to meet the demand for his work. The student soon acquired proficiency in depicting prunus blossoms, humans, horses, fantastic trees, and weathered rocks—all of Jin Nong's specialized subjects. Jin Nong, a well-known connoisseur of antiques, also passed this knowledge to his protégé, Luo Ping.

The relationship between master and pupil ended when Jin Nong died in 1763. Luo Ping continued to show his devotion by taking care of Jin's funeral and in subsequent years spent time, energy, and money to travel to various places to collect Jin's dispersed poetic writings and publish them in one volume.

Following the death of Jin Nong, Luo Ping painted for a living, often collaborating with his wife, Fang Wanyi (1732–1779), sons, Luo Jieren and Luo Xiaofeng, and daughter, Luo Fangshu.[4] The Luo family was particularly well known for paintings of prunus blossoms.

Two years after the death of Jin Nong, Zheng Xie also died. With their passing, Luo Ping became the only major painter in Yangzhou. From 1771 to 1798 he made three trips to Beijing.[5] He was befriended by high officials, eminent scholars, and painters, who all thought highly of his artistic skill. Yet, he lived a solitary, destitute life, turning more and more to Buddhism for spiritual solace. It was only with the financial assistance offered by Zeng Yu (the Liang Huai salt commissioner in Yangzhou) that Luo Ping was able to return home in 1798. He died the following year.

Luo Ping was a versatile painter. Subjects ranged widely. Besides landscape, figures, animals, birds, and flowers, he even painted ghosts, claiming that he possessed preternaturally discerning eyes.[6] His early works show that he followed Jin Nong's painting style closely.[7] In subsequent years, after many opportunities to see paintings by important painters in the collections of his Beijing friends, he eventually developed his personal style. This change was also necessary because his clientele in the capital had totally different tastes in painting.

This album, dated 1781, was executed in Yangzhou after his second trip to Beijing. It depicts various animals and plants. The images are all done in the *mogu* (boneless) manner, with details defined by a few casually drawn lines. Similar to most other works done in the album format, they are all depicted as close-up views. Some (leaves 6, 7, and 8) are represented so large, however, that they fill up the greater part of the painting proper, while others are designed with a spacious composition (leaves 2, 5, and 9).

Variety is also evident through Luo Ping's virtuoso manipulation of the brush and ink. With a few economical strokes he captures the delicacy of the buds and fresh

blooms of the lotus, tuberose, and narcissus (leaves 4, 7, and 10). Using three distinctive brush manners, he creates the different forms of their leaves with equal facility. They range from precise strokes to represent the spindly leaves of the narcissus, controlled broad sweeps to depict the heart-shaped leaves of the tuberose, and spontaneous smears to suggest a large lotus leaf swaying in a light breeze.

Luo Ping also handles the ink-wash technique with great skill. He knows exactly the amount and the intensity of diluted ink needed for an effective portrayal of each subject. The leaves of the tuberose, for instance, are depicted with four or five tones of ink, from light grey to black, to enhance its visual attraction. Two tones of grey are subtly merged to distinguish the upper side (darker) and the underside (lighter) of a drooping leaf at the right. The fuzzy silhouettes of two chicks (leaf 3) and the rabbit (leaf 9) suggest convincingly the soft and fluffy quality of their furry coats. Also worthy of note is the method used for painting the peony (leaf 1) and the rabbit. The individual petals of the flower rendered in a variety of shapes are separated from one another by leaving a sliver of untouched space around their edges. For the rabbit rendered in a fore-shortened perspective, the same idea is applied to ensure its head and two long ears are distinguishable from its round body.[8]

The most interesting work in this album, however, is the one depicting a cluster of grapes (leaf 6). It exemplifies ink play at its best. The ink splashes that form the unkempt foliage, the vigorous strokes that give shape to the entangled vines, and the flying curves that delineate the resilient tendrils all testify to the burst of energy emitted from Luo Ping's brush and the incredible speed with which he transmits his fugacious inspiration onto paper. In contrast, the luscious grapes, executed in the palest tone of diluted ink as carefully arranged discs, project a sense of calmness. The intriguing interplay between the various compositional elements simply delights the eye.

12

Anonymous European painter
Drawings of Chinese Figures

Album of 48 drawings

Ink and colour on paper

Qing dynasty, ca. 1800

Image sizes vary

University of Alberta Museums

Mactaggart Art Collection

2004.19.2.1–48

© University of Alberta Museums

THIS ALBUM contains 48 ink and watercolour drawings, most tipped onto native paper. Forty-four of them depict Chinese subjects; four depict Indian subjects. Although the drawings are not arranged in a systematic manner, the Chinese subjects, which depict men and women either singly or in small groups, can be divided into five categories: government officials, ordinary people, customs, transportation, and punishment. In most cases, each figure is numbered and identified in English.

The first category encompasses images of different ranks of military and civil officials, soldiers, and attendants. While some pose in their official garb, others, who hold various kinds of weapons, assume fighting stances.

The second category consists of mandarins and their servants, merchants, country folk such as a fisherman, a woodman, a country woman, and a dancer, Buddhist monks, Daoist priests, and beggars.

Making up the third category are the images of a couple in mourning and scenes of footmen carrying a hearse, a bride and groom, and a Manchu woman standing side-by-side with a Han Chinese woman, both women are distinguishable by the traditional costumes they wear.

The fourth category shows different kinds of vehicles, including a mountain chair carried by two porters, a wheel-chair pushed by an attendant, a cart mobilized by a puller in front and a pusher at the back, and palanquins

carried by porters that range in number from two, four, to eight, depending on the riders' social status.

The last category illustrates criminals undergoing torture (face-slapping, spanking, ankle-squashing, confinement in a small cage, and wearing a cangue) and capital punishment.

These subject categories were the staple of figural themes in Chinese export watercolours. In the late eighteenth century, artists living in the several seaports of south China started producing visuals to satisfy Westerners' curiosity about the Chinese way of life. These visual snippets reached interested clients in Europe and America via two channels. Most were shipped along with other popular trade goods—silk, tea, ceramics, furniture, and embroideries. A small number were carried back home as souvenirs by travellers to China.

In addition to large-scale indigenous production, visiting Western artists drew topographical scenery, architecture, flora and fauna, as well as scenes of daily life. George Chinnery (1774–1852) is a good example. This adventurous English painter travelled to India (1802–1825) and then to China (1825–1852). He established himself as the foremost portraitist and painter of topographical pictures and genre subjects in both countries.

Unlike Chinnery, who lived the better part of his life in the Orient, most Western artists stayed abroad for short

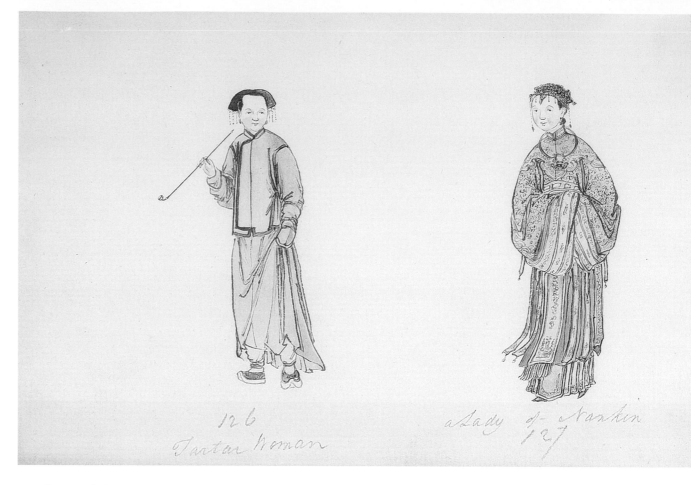

Leaf no. 17, Two women in their national costume—Chinese (right), Manchu (left).

126
Tartar Woman

a Lady of Nankin
127

periods to search for exotic themes that added to their repertoire.

One such person was William Alexander (1767–1816). Alexander went to China as draftsman to George Macartney's embassy between 1792 and 1794. Although he did not see much at the beginning of the trip due to the Chinese government's reluctance to receive the uninvited foreign envoy, he managed to make many detailed sketches of China's hinterland on the embassy's return trip from Beijing to Canton via the inland canal. These sketches formed the basis of numerous drawings and engravings he produced in subsequent years. His visual records became so popular at home that they are considered largely responsible for the general perception of China in the West.[1]

Another person who also influenced Western ideas of China was George Henry Mason. An English soldier by profession, he was stationed in Madras in India around 1790 when he became ill.[2] At his doctor's recommendation he was transferred to Canton (Guangzhou) to recuperate. His stay lasted a few months. Mason was quite curious about life in China and managed to circumvent restrictions imposed on foreign visitors to the city by using all his diplomatic tact. He gleaned information from people he encountered, including his fellow countrymen residing at the British factory and the Chinese *Hong* merchants. In addition, he obtained correct drawings of the Chinese in their respective habits and occupations; the itinerant mechanics and handicraftsmen, in particular.[3] The drawings were made by Pu Qua, one of many

Leaf no. 24, A Governor-General in official attire.

Cantonese export watercolour painters. They became the basis of copperplates made by Dadly from which coloured engravings were produced by William Miller between 1799 and 1801. Two books illustrating these drawings with short descriptive texts in both English and French were subsequently published. One was entitled *The Punishments of China*; the other was known as *The Costume of China*.[4] Both books became important references on the Chinese penal system, costumes, and street trade.

The album under discussion was ascribed to Thomas Daniell (1749–1840), an English painter who travelled to India and made a name for himself during his ten-year sojourn. For some unknown reasons, the 1785 voyage that he and his young nephew, William Daniell (1769–1837), took brought them first to Canton in south China before delivering them to Calcutta.[5] The Daniells' Chinese experience could not have been very deep because of their short stay and because of the restrictions placed on foreigners by the Chinese government. This is perhaps why years later, when Thomas Daniell published *A Picturesque Voyage to India; by the Way of China* in 1810, he had to rely on figure types popularized by Chinese export paintings. The book's few aquatints feature stereotyped Chinese figures, such as a military officer, a gentleman, a Chinese of rank, a barber, and a husbandman.[6] Although all are furnished with appropriate settings (landscape or indoor), the figures are staged and shown prominently in the foreground.

What is most interesting is the image of the military officer. He is almost the exact mirror image of a similar figure (no. 57) in the present album. To be more precise, this figure is similarly decked with flags on his back, wears the same helmet, and carries his quiver filled with arrows and his bow in an ornamented case. His uniform, however, is similar to another military figure (no. 58) drawn beside no. 57. Yet, such similarities cannot be regarded as evidence

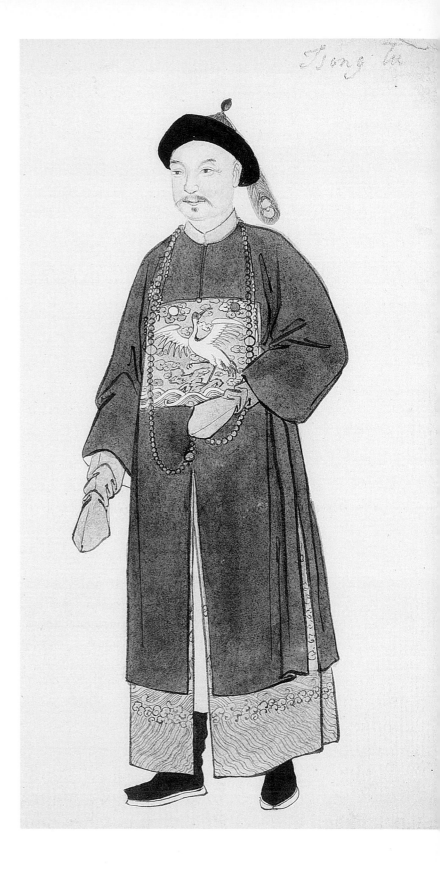

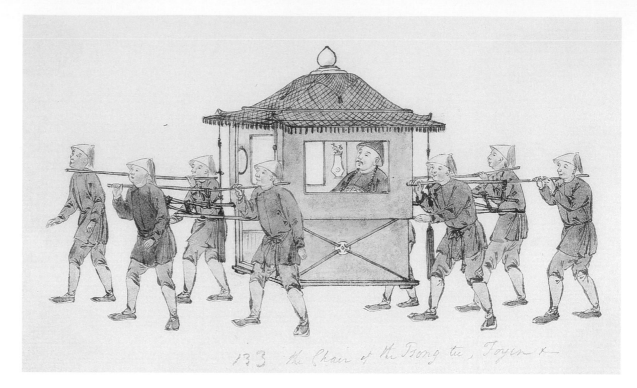

supporting the assumption that this album was by the hand of Thomas Daniell. If they were indeed by him, he would have had a large stock of studies of Chinese figures from which to draw inspiration. Therefore, he would have produced far more aquatints of Chinese figural subjects than he did in his 1810 publication.

In fact, many figures depicted in this album do not appear to be records of direct observations made by the painter. Scenes of punishment, for example, are either exact copies or adaptations of those illustrated in *The Punishments of China*.[7] As well, a drawing that portrays an old man labelled as a *foyen* (*fuyuan* or governor, not numbered) and another that shows a man in military garb and labelled "No. 1 Tartar Prime Minister" (no. 130) also have their sources in *The Costume of China*.[8] Such evidence suggests that, like George Henry Mason, the painter of this album collected sets of watercolours made by Pu Qua or other export painters. Additionally, there is a possibility that he may have had knowledge of the two books on Chinese costume and punishments.

Two phenomena make the drawings in this album even more intriguing. The expressive faces, the subtle but effective facial modelling that highlights bone structure, the excellent execution of the hands, and the well-proportioned figures all point to a painter versatile in Western painting techniques. Misrepresented or ambiguous details, such as the veil of the bride (no. 103) and the hat ornament of the groom (no. 104), Westernized faces (nos. 6, 49, 58), and clumsy depiction of drapery folds in certain cases (nos. 3, 48, 54, 55, 133) also support this view. Yet, strangely many figures are depicted with very fluid descriptive lines that vary in thickness (nos. 45, 46, 105, 106, 128, 129). They show dexterity with the painting brush that would have taken years to acquire, a quality atypical of a Western painter.

Added to these observations is the fact that four drawings that depict Indian horsemen and weapons are included at the end of the album. Their style of execution is entirely different from that used for the Chinese figures. Can their presence be taken as an indication that the painter was one of those adventurers who had visited both China and India? Obviously, more research is required to solve the mystery.

Anonymous Chinese export
watercolour painter(s)
**Drawings of Flowers
and Insects**

Album of 30 drawings
Ink and colour on paper
Qing dynasty, ca. 1810
35.5 x 43.2 cm (each leaf)

University of Alberta Museums
Mactaggart Art Collection
2004.19.3.1–30
© University of Alberta Museums

THIS ALBUM is bound in half morocco and marbling paper, with gilt lettering, "Chinese Drawings," stamped on its front cover. Before it entered the Mactaggart Art Collection, it was in the possession of at least three other collectors: P. Dheulez Mambeolain (?), Sir Thomas Phillipps (1792–1872), and Philip Robinson (1902–1991).[1]

The 30 watercolour drawings depict plants and insects. The plants are mostly in bloom, with butterflies, moths, or wasps hovering about. A few have an additional insect or two crawling on their branches. About 20 leaves display only studies of insects.[2] They are represented in different attitudes and positioned randomly. Notwithstanding the casual layout, the flying insects are drawn in the upper half of the sheet while the crawlers are relegated to the lower half. There is no indication of a ground plane.

The plants include bamboo, gold-silk peach (*Hypericum monogynum; jinsitao* in Chinese), strawberry begonia (*Saxifraga stolonifera; hu'er cao*), catalpa (*Catalpa bungei; qiu*), yellow thorny rose (*Rosa xanthina* f. *Spontanea; huangcimei*), rose (*Rosa rugosa; meigui*), wild rose (*Rosa multiflora; ye qiang-wei*), Straits rhododendron (*Melastoma malabathricum*), peach, and double gardenia. Counted among the insects are the butterfly, moth, wasp, beetle, cicada, grasshopper, praying mantis, dragonfly, fly, horsefly, and spider, some represented in more than one variety. The meticulous draftsmanship and realistic execution not only capture their images with great fidelity, but also impart a strong sense of their delicate existence.

Most of the plants are depicted as broken branches. The bamboo and the strawberry begonia are the only exceptions. The bamboo stem has artificially induced cross-sections at both ends. The vertical one at the top reveals the culm's cortex and pith cavity without the epidermis. The diagonal one at the bottom shows the cortex when it is protected by the epidermis. The two clusters of strawberry begonia are complete with roots. The painter's intent to show the physical structure of these plants and his carefully planned arrangement of the branches, foliage, and flowers make it clear that these are botanical watercolours made for export.

A strong interest in exotic *flora* developed in Europe during the sixteenth century. Carolus Clusius (Charles de L'Ecluse, 1526–1609), a leading Flemish botanist, is credited for being the first scientific horticulturalist to introduce and distribute throughout Europe many exotic garden plants. He played a major role in transforming the composition of northern European flower gardens, which before 1560, contained a limited selection of ornamental plants. His friend, Joachim Camerarius (1534–1596), a renowned Nuremberg botanist and physician, often received seeds and cuttings from him, many of which were sent from the New World, Asia Minor, and the Far East. Camerarius not only enriched his own garden with these seeds and cuttings but also planted flowers grown from them in the greatest German garden of the time, the gardens of the Prince Bishop at Eichstätt, which he had

p. 54: Leaf no. 11, Gold-silk peach (Hypericum monogynum) *with cicadas and a butterfly*

p. 55: Leaf no.2, Section of a bamboo stem *with bees hovering over a beehive.*

been commissioned to design and supervise its original layout.

Although the gardens of these famous owners may not have been accessible to many people, images of many plants grown there were recorded for admirers to see. Camerarius's nephew, Joachim Jungermann (1561–1591), is generally believed to have painted the Camerarius Florilegium around 1589, an album that portrays 473 ornamental plants with names identified in Latin. Following this exemplary manuscript, Basil Besler began the production of the *Hortus Eystettensis* in 1606. When completed in 1613, it became another important work with 367 engraved plates documenting the ornamental plants from the Prince Bishop's garden. Judging from the large numbers of old European botanical paintings and engravings that still exist, the demand for plant illustrations was considerable from the seventeenth century onward.[3]

In the days before the invention of photography and before efficient travel and enhanced scientific knowledge increased the success rate of preserving and transporting plant specimens from overseas countries, the next best thing for plant enthusiasts was to obtain painted or printed images that featured plants in different stages of growth or in their prime.[4] It is, therefore, hardly surprising that botanical illustrations constituted one of the much sought after items in the China trade.

Based on extant examples, at least three kinds of botanical drawings were made for the Western market, with Canton (Guangzhou) being the main centre of production. One kind was executed on Western paper, typically made by J. Whatman of London or A. Cowan and Son, also of London. The images rendered in watercolour followed closely Western painting techniques to suit Western aesthetic taste. Another kind was executed on sized Chinese mulberry paper called the *mianlianzhi*.

The realistic images, also drawn in watercolour, were often accompanied with plant names written discreetly in Chinese. The third kind used gouache and pith paper (made from the *tongcao* or *Tetrapanax papyrifera*) as painting materials.[5] The strongly coloured images were more decorative in feeling and less accurately represented.

Depiction of plant life was a familiar subject for China trade painters. They had two long traditions to draw upon. Since the Tang dynasty, bird-and-flower paintings were one of the major subject categories. Book illustration, too, was another source. Beginning at least from the

Leaf no. 12, Three butterflies and
two crawlers.

Song dynasty, important materia medica were furnished with images as visual aids to texts—although these were mostly rudimentary line drawings that suggested only general ideas of the plants described.

Armed with substantial knowledge gained from these traditions, China trade painters working during the latter eighteenth century could quickly adapt their traditional painting concepts and techniques to meet Western aesthetic standards, whether copying models provided by their foreign clients or creating their own compositions.[6]

The drawings in the album under discussion are executed on Whatman paper. They belong to the first kind of botanical watercolours mentioned above. The quality of the drawings varies. Some are exquisitely done. A few are less refined. This phenomenon suggests more than one painter at work. Western painting manners are particularly conspicuous in certain details, such as the precise description of the veins on both sides of a leaf to bring out its plasticity; the naturalistic modelling of some of the flower branches; and the interest in depicting shadows of objects cast by a fixed light source, evidenced in the images of the crawlers in the studies of insects.

Su Renshan (1814–1850)
Luohan

Hanging scroll
Ink on paper
Qing dynasty, ca. 1847
81.3 x 35.3 cm

University of Alberta Museums
Mactaggart Art Collection
2004.19.52.1
© University of Alberta Museums

SU RENSHAN was born in Xingtan, a village belonging to the administrative county of Shunde in the southeastern coastal province of Guangdong. His father, Su Yinshou (1788–1862), was a government tax collector who dabbled in painting and calligraphy in his spare time. Most likely, under their father's tutelage Renshan, the eldest son, and Jixiang, a third son, acquired rudimentary skills in these two art forms.

As a precocious child, Su Renshan wasted no time in preparing himself for the future. In a lengthy inscription written on a painting he did in 1841, he recalls that at the ages of five and six he already practised writing characters on any surfaces within reach, including doors and walls at home. From seven to eight, he could paint landscapes and objects. At nine, he was so immersed in the study of classical texts that he had no time for painting. During the following two years, however, he managed to paint after study hours. By the age of twelve, people in his hometown were well aware of his painting skill. At thirteen, his knowledge of the classics spread among fellow students preparing for the civil-service examination at the district level. At fourteen, he visited the city of Guangzhou. At fifteen, he copied large characters in clerical script from calligraphic models with a passion. At sixteen, he devoted his time to studying the skills of writing "eight-legged essays."[1] Over the following two years he immersed himself in poetry and the theories of Neo-Confucianism.

At nineteen, he felt confident that he had acquired sufficient knowledge so he sat for the civil-service examination. He failed. He then spent the following two years reviewing a wide range of model answers to political questions posed in past examinations. He became well versed in social rites. At twenty-two, he sat for the examination again, but once more failed. Totally disillusioned, he made up his mind at twenty-three to abandon further efforts to pursue an official career.

From then on, Su Renshan focused on painting and calligraphy. Information about his life after this turning point, however, is sketchy and sometimes speculative. For example, it is not certain how he made a living, since Su Renshan had only vaguely mentioned that he used his brush and inkstone as a farmer would use a plough to work the field. This could mean he offered his services either as a tutor, or a writer, or a painter, or all of these. He was married at the age of twenty-seven. Unfortunately, the marriage was not a happy one. Not long after, he may have committed some wrongful deeds and was banished by his clansmen. He travelled to Wuzhou in neighbouring Guangxi province and stayed there for several years. At the age of thirty-five, he returned to his hometown. His father brought charges against him for filial impiety. The cause for the grievance was vague. Several scenarios have been suggested by researchers, based on oral traditions that still circulated in Shunde during the first half of

看毋咸形呂父牟性脩性知天
脩形告命大人踐形君子俟命未
能洞達先求古書積日累月星
稽星居戲馴而畜人良之師肖
在有定凍凝不志婁肖壯夫自
此古黑在世遠宮出世於此蒙
求覺悟必何如陽明知能一以良
離白沙天理百目靜誅奮兑金全
躍若古著茲廣宗術宗皆之所
資佛空四大仙壽叔鉅兩習以趂叄墨㵧溺

the twentieth century. Su Renshan may have angered his father because he refused to do a painting that his father had promised the magistrate. Or, Su Yinshou thought it safer to sever any ties with his son because Su Renshan had harboured treasonous feelings against the Qing government, a crime that, if proven, could bring disaster to the family and even the clan. Or, worse still, animosity arose between father and son because either the father took an interest in the son's wife or the son did something disrespectful to his step-mother.[2] In any case, Su Renshan was imprisoned and died within a year or so, at the young age of thirty-seven.

Su Renshan was a prolific painter. He claimed to have produced more than a thousand paintings when he was around twenty-seven years old.[3] Since he continued to paint until his premature death, he may well have painted a few thousand works during his short life. In subject matter, he specialized in landscape and figural themes. Occasionally he painted plant life. Although his father initiated him into artistic matters, in all probability he was driven by his own passion to seek out ways to advance his knowledge and techniques. Since there were few painting collections in Guangdong and he had no access to any of them. Options opened to him were limited to keenly observing nature, people, and activities that took place around him; diligently copying ink rubbings of calligraphy and pictures taken from stone stelae; and studying painting manuals and book illustrations. His hard work paid off. He acquired fluency in representational and compositional skills at a very young age. Yet, because he lacked opportunities to see real works by renowned painters, the brush manner he eventually developed shows prominent influences from woodblock-printed images rather than any of the established styles he claimed to have inspired him.

This painting depicts a *luohan* (Sanscrit, *arhat*) sitting on a round mat, with a set of books beside him.[4] *Luohans* are sages who possess transcendent powers. Being immune from the cycle of suffering and rebirth, they live extended lives and act as protectors of the doctrine of the Law until the future Buddha, Maitreya, arrives. Since the concept is Indian in origin, the foreignness of a *luohan* is emphasized here. His hirsute characteristic is amply described in the face and the exposed chest, arms and legs. His bald and protruding cranium, long ear lobes, and the set of scriptures are all signs indicating his wisdom. The casually worn voluminous robe, with sleeves pushed up and the lower part gathering in heaps on the ground, is equally significant. The predominantly parallel angular lines describing the bunched-up folds create an illusion of a multi-faceted rock formation that may have been intended to imply a *luohan's* long life and dependability. Also of interest are the *luohan's* pose and expression. He sits with one foot crossed over the other. Leaning forward, he supports his body weight by resting his left hand on the heel of his right foot. The agitated fingers and raised palm of his right hand suggest he is tapping his right thigh. This animated gesture clearly shows that the *luohan* is not meditating, but rather, judging by his open mouth and concentrated look, chanting with rapture.

The lengthy inscription written above the *luohan* reads:

A mother gives [a person his] form.
A father gives [him his] nature.
Cultivate the nature [and he] will know [the designs of]
Heaven.
Cultivate the form [and he] will understand [what] destiny
[has in store for him].
A great man acts according to ethical norm.
A gentleman waits for destiny [to unfold].

[Anyone who] cannot grasp [this idea],
Should search [for answers] in ancient writings.
Day after day and month after month,
[He should continue to] investigate and put into practice
[his findings].
Tame animals are conducive to domestication.
Men of fine character may be taken as models.
These facts are clear and constant.
[As also] movement is incompatible with coagulation.
There is a healthy man.
He likens himself to an ancient fool.
In his daily life he [tries to] stay out of harm's way.
He is all too happy to live in the world of immortals.
To rid ignorance, he strives for an awakening,
[Through] ways of enlightenment.
[Wang] Yangming upheld his theory of conducting oneself
according to one's conscience.[5]
[Chen] Baisha advocated the idea of the universe being the mani-
festation of the human mind,[6]
[Attainable by] meditation in complete silence day by day.
Hawks soar [in the sky]; fish bounce [in deep water].
[These are] clear [phenomena] to keep in mind.
[Whether] the Guang school or the Zhe school,[7]
Each must have its own basis.
Buddhism preaches that the "four greatnesses" are empty.[8]
Immortals enjoy longevity; their bodies can last for aeons.
These are believed by followers.
[I merely] point out a notable feature of each of them.

This long inscription provides insight into Su Renshan's philosophical thinking. It summarizes some of the basic concepts he perceived from three traditional beliefs, Confucianism, Daoism, and Buddhism, as well as Neo-Confucianism. Although it hardly sheds light on the depicted subject, it plays an important role in the

overall design of this work. Viewed as a large square block made up of vertical rows of characters, its structured form invites comparison with the simply and spontaneously executed oval mat the *luohan* sits on. The animated stance of the characters and the incisive quality of each brush stroke are in complete harmony with the brushwork evident in the image of the *luohan* and the signature (*Renshan shuhua*, calligraphy and painting by Renshan) located in the lower left corner. They constitute a subtle element to unify the three distinct components in this work. Also worthy of note are the two unusually large and bold characters, *shuhua*, written with a great flourish evoking the vision of a dancer waving a long ribbon as she glides through a few improvised dancing steps. They exude ecstacy and may well reflect his state of mind as he came close to the completion of this work.

Paintings of *luohans*, whether singly or in groups of sixteen or eighteen, have been produced since the Tang and Song dynasties. They served many purposes, for example, as worshipping icons, as temple offerings for donors to accumulate merits for their afterlife, and as gifts that would bring blessings of luck, longevity, and progeny to the recipients. It is not clear whether Su Renshan created this painting for his own enjoyment or for some other purposes.

Of interest is the fact that there are other paintings of *luohans*, represented singly and in a group, among Su Renshan's extant work.[9] None of those depicting a single *luohan* is executed with as much attention to details as the work under discussion. In addition, two seal impressions, *qizu* (seventh patriarch) and *Renshan*, are located beside the two highly stylized characters, *shuhua*. Since the earliest extant painting bearing the same seal impressions is dated 1847, this painting of a *luohan* may have been painted between this time and the year he died.[10]

Anonymous court painters
Battle Scene from the
Nian Rebellion

Wall-mounted painting
Ink and colour on silk
Qing dynasty, later 1870s
136.1 x 303.8 cm

University of Alberta Museums
Mactaggart Art Collection
2004.19.49
© University of Alberta Museums

THE GOLDEN AGE CHINA experienced during the reign of the Qianlong emperor (1736–1795) vanished with the passing of that era. In the nineteenth century, the weakened Qing government was beset with many internal and external problems, notably natural disasters, economic setback, uprisings, and foreign invasion. Two serious threats to the dynasty—the Taiping Rebellion and the Nian Rebellion—occurred in mid-century. In 1850, the Taiping Rebellion began in the south under the leadership of Hong Xiuquan (1813–1864).[1] Its mission was to overthrow the Manchus to re-establish Han rule. Many people who joined the campaign fought fearlessly. At its height, the movement controlled the southern part of central China, in particular the rich lower Yangzi region. Its good fortune, however, came to an end in 1864 as a result of internal power struggles and the emergence of able military commanders on the Qing side.

While the Qing forces were occupied with the Taiping rebels, another uprising spread in the southern part of the north China plain, especially along the route of the Grand Canal. Despite lack of central leadership and political or religious ideology, the Nian bands, which were originally composed of bandit groups, attracted and absorbed many impoverished peasants and victims of the heavy Yellow River floodings of 1851 and 1853. They built fortified villages and employed guerrilla tactics and swift cavalry movement. From time to time they raided other towns and villages, taking crops, robbing merchants, kidnapping wealthy land owners for ransom, and holding up government salt transports.

By 1855, when Zhang Luoxing was proclaimed the commander, the Nian had grown to eighteen groups with a total of 30,000 to 50,000 fighting men, with each group organized under its own banner. In 1860, the Qing government ordered General Zenggelinqin to quell the rebels. He succeeded in killing Zhang Luoxing but was in turn ambushed and killed by the avenging Nian in another battle. It took four more years before Zeng Guofan (1811–1872) and Li Hongzhang (1823–1901) could finally crush the Nian in Shandong province and execute all the captured adherents.[2]

Both the Taiping Rebellion and the Nian Rebellion had devastated large areas in China.

To commemorate the success in suppressing these insurrections, the Qing government followed the Qianlong emperor's example by commissioning pictorial records of significant battles. Several sets of battle scenes were produced, probably during the later 1870s.[3]

This work belongs to a set of 18 paintings of the various battles waged against the Nian Rebellion. It depicts enormous Qing forces arriving from different directions in the countryside to launch an attack on a Nian stronghold. There are cavalry troops aided by foot soldiers in hot pursuit of fleeing rebels in the foreground and infantrymen swarming into a fortified village in the middle ground on the left. The dominance of the Qing

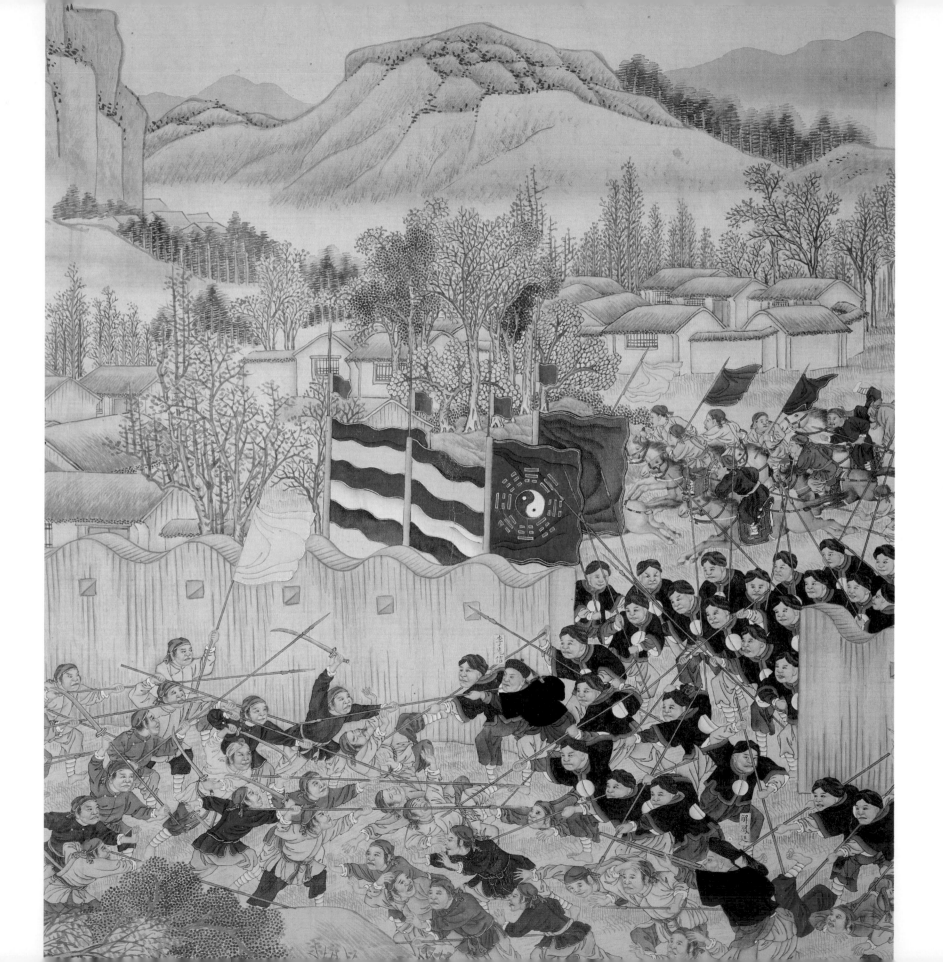

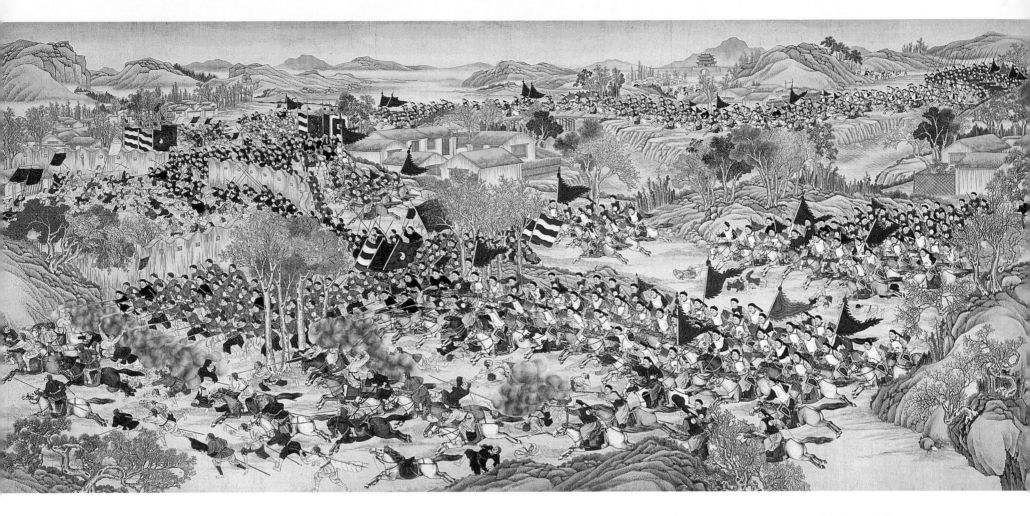

p. 62, Detail from Battle Scene from the
Nian Rebellion.

army is obvious not only in number but also in military equipment. Their cavalrymen are armed with rifles or bows and arrows, both advantageous for long-range assault. The infantrymen use lances as weapons. The vastly outnumbered rebels, however, have nothing but swords and spears to fend off their assailants. The odds against them are so great that it is amply clear defeat is inevitable and imminent.

Inside the fortified Nian village, some die-hards are seen still waving their solid colour banners of yellow, red, blue, and black while others fight for dear life. These banners provide helpful clues for identifying who the villagers are.[4] Another clue—the undulating palisade with peepholes enclosing the village—links this painting with another painting, no. 17, in the same set. The latter also

depicts similar Qing contingents pursuing the Nian rebels, many passing by a palisade with identical architectural features seen along the right-hand side of the painting's lower border.[5] Since this other painting has been identified as a battle fought at the south town of Chiping, located in western Shandong province, perhaps the battle captured in the present painting also took place somewhere within the same province.[6]

The composition of this painting is very well planned to maximize visual impact. Elements of contrast and diversity have also been infused into it in large measure for the same purpose. Taking centre stage in the foreground, the blood-curdling scene of massacre is large. Galloping horses with their riders charge forward with a thundering noise. Commanding officers yell out orders

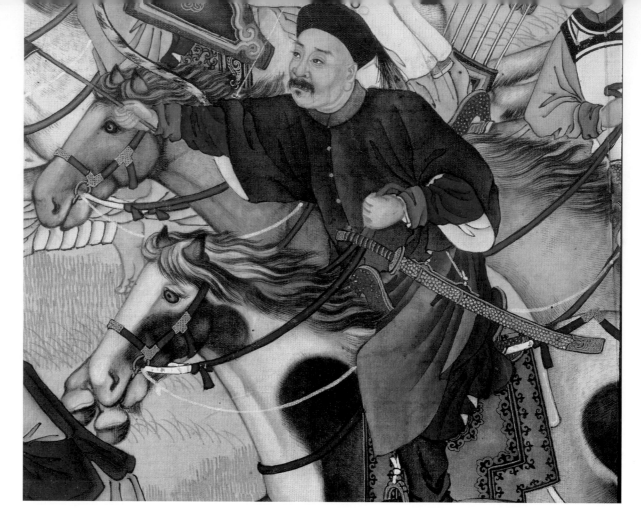

Detail from Battle Scene from the Nian Rebellion.

and soldiers fire at close range upon the cornered rebels. The wounded scream with pain and the dead are left sprawling on the ground. Further back, in the middle ground, another kind of fighting takes place—Qing soldiers and rebels engage in hand-to-hand combat. These action-packed scenes take up most of the painting proper. By contrast, in the far distance in the upper right corner, small numbers of refugees are depicted slowly leaving their homes behind through a gate. Their bent bodies and the few possessions they carry speak for the suffering of innocent people embroiled in political conflicts.

Elements of contrast are apparent in the opposing directions the rebels and the few refugees move in relation to the right-to-left advancement of the overwhelming Qing forces. Contrast is also evident in the orderly and confident approach of the imperial cavalry and infantry versus the helter-skelter fleeing attempt made by the desperados. This is complemented by a sense of incongruity emanating from the nature of the subject (battle) and its setting (a serene landscape with blooming trees and well-tended houses). Irony can also be felt through the attractive colours used to depict the various banners and uniforms of the imperial forces. Underlying these prevailing colours lurks danger and violence.

This battle scene has been dramatized to glorify the Qing forces' victory over the Nian rebels and cannot be taken as a true record of what actually transpired. Nevertheless, it gives us an artist's impression of what might have happened and a good sense of the abilities of some of the painters serving the imperial court during the latter half of the nineteenth century.

Shi Lu (1919–1982)
Cliff Landscape

Hanging scroll
Ink on paper
Early 1960s
136.3 x 68.5 cm
2004.19.84

Permission from the copyright
holder to reproduce this image was
not available at the time of
publication of this catalougue.

Please refer to:
www.museums.ualberta.ca/mactaggart
for more information.

SHI LU'S original name is Feng Yaheng. He adopted the new name of Shi Lu when he was twenty-one years old. This name change was to show his admiration of Shitao (1642–1707) and Lu Xun (1881–1936), two leading artistic and literary figures known for their individuality and outspokenness.

Shi Lu hailed from a very wealthy family in Renshou district in Sichuan province. Although the family made its fortune by selling herbal medicine and cotton, it has produced scholars in several generations after migrating from Jingdezhen in Jiangxi province. The Feng clan was well known for its substantial library of hundreds of thousands of volumes of books.[1] Growing up in this intellectual atmosphere, Shi Lu had a good foundation in the classics and literature. At sixteen, he began studies in traditional painting in Chengdu at an art school founded by his second elder brother. After graduation, he returned home to teach drawing in a primary school.

Shi Lu could have led a comfortable life at home, but instead at nineteen he ran away to study at West China Union University in Chengdu. There he learned about Mao Zedong (1893–1976) and became fascinated by Mao's vision of changing China. He dropped out of school a year later to travel to a northern Shaanxi Communist base where he participated in propaganda work—first against the invading Japanese and later against the Nationalists during the civil war. The illustrative materials he produced

at this time ranged from woodcuts, cartoons, New Year pictures, and serial storybooks. In addition, he also served in many other capacities, including script-writing, play-directing, stage-set design, editorial work, art criticism, and teaching.

After Liberation in 1949, Shi Lu resumed painting in the traditional manner. He often travelled to the frontier provinces of Gansu and Qinghai, as well as to the loess uplands in northern and southern Shaanxi to make sketches. In 1955 and 1956, he was sent to India and Egypt to attend international symposia on art. All these experiences gave him a wide range of subjects for representation. He produced a number of successful paintings and held several exhibitions to wide acclaim. Some works, such as *Turning to Northern Shaanxi to Fight* (1959), *Horses Drinking at the Yan River* (1959), and *On the way to Nanni Bay* (1961), were particularly lauded for their originality and historical significance.[2]

In 1952, Shi Lu made Xi'an (ancient name: Chang'an), the capital city of Shaanxi province, his permanent home. For this reason he was recognized as one of the leaders of the Chang'an school, an art movement that espoused the use of free and bold brushwork to depict the harsh landscape of Shaanxi province and the lives of the peasants. However, his popularity began to spiral downward in 1964. His painting style was criticized for being "wild, eccentric, chaotic, and black." What had once been touted

as his masterpiece, *Turning to Northern Shaanxi to Fight*, was chastised for having committed a politically incorrect mistake—placing Chairman Mao on the edge of a cliff—one that was construed as suggestive of ideological deviations. Shi Lu was vocal in defending his innocence and stubborn in refusing to submit himself to correction. As a result, he continued to be persecuted during the Cultural Revolution and eventually succumbed to mental collapse. His reputation was not restored until 1978. By that time he was already seriously ill. Yet, in spite of his sickness, he fervently began painting, exhibiting, lecturing, and overseeing of the affairs of the Shaanxi Artists' Association. Unfortunately, his health deteriorated quickly and he died prematurely in 1982. Before he died, he expressed regrets about not having the time to accomplish his visions.

Shi Lu's artistic development may be divided into three stages. During the 1940s and mid-1950s he produced mainly visual materials of a political propagandistic nature. From the mid-1950s to the early 1960s he changed his focus to depicting the lives of the peasants living in the loess highlands in Shaanxi province and portraying the Communist ideals and accomplishments in the new China. Towards the end of the Cultural Revolution he abandoned the naturalistic emphasis in his earlier works, replacing it with an idiosycratic and highly expressionistic style.[3]

Cliff Landscape depicts a small boat travelling down the Yellow River at Longmen.[4] This is a critical point where the mountains on both sides of the river converge, leaving a gap of only about a hundred metres wide for the river to continue its course. The constricted water flow at this point causes turbulence, creating enormous hazards for people travelling up and down the river.

Shi Lu captures the grandeur of this notorious section of the Yellow River by depicting the scenery from a bird's-eye view. The high vantage point makes the viewer feel as if he or she has been transported right to the top of the cliff at the bottom of the picture plane and is looking down a chasm as far as the view permits the eye to see. The sheer height of the cliffs and the whirling motions of the water are frightening enough to make one feel dizzy. The tiny boat skirting the edge of a cliff sets the scale of the formidable surroundings. Its minuscule size makes one worry about the safety of the boatman as he navigates gingerly down this particularly treacherous stretch of the river. It also evokes a sense of the frailty of human life in the face of nature's hostile forces.

To further enliven the scene, Shi Lu uses broad and lighter ink washes to capture the mountains in the background and the lower parts of the cliffs, relying on the blurred images they produce to suggest distance and mists. He also manipulates his brush as if it were a carving knife, twirling, twisting, jabbing, and dragging it in a seemingly random manner. His technique leaves ink marks that define clefts, crags, or jagged edges. The diverse texture strokes and sharp tonal contrasts not only convincingly portray rugged rock surfaces but also create many intriguing abstract patterns. Furthermore, the nervous energy imparted through this unconventional manner of execution imbues the landscape with a vivid sense of restlessness. Also of interest is Shi Lu's signature located at the lower right corner of the painting. The two characters are written with the same angularity evident in the contour of the precipice on the right-hand side. They blend so well with the painting that they seem to be carved on the rock face, hardly perceptible until one notices the image of a red seal impression, the only touch of colour, painted beneath them.[5]

Although *Cliff Landscape* is not dated, it compares particularly well with two of Shi Lu's published works: *Sailing Against the Currents through the Yu Pass* (1961) and *Red Cliffs Reflected in the Green River* (1962).[6] The former depicts a boat and two rafts travelling up the Yellow River at the same location, with the additional interest of a team of boat-pullers toiling along the rugged cliff edge to drag the boat upstream. The latter depicts three separate boatmen guiding their boats downstream with caution. Both are executed with ink and colour. Although very interesting works in their own right, they are visually less dynamic when viewed against this monochrome painting.

Yang·Shanshen (1913–2004)
Sparrows in a Bamboo Grove

Hanging scroll
Ink and colour on paper
1984
135.7 x 34.7 cm
2004.19.80

*Permission from the copyright
holder to reproduce this image was
not available at the time of
publication of this catalouge.*

*Please refer to:
www.museums.ualberta.ca/mactaggart
for more information.*

YANG SHANSHEN was born in Chiqi in Taishan county, Guangdong province. His literary name was Liuzhai. A blessed man in every way, he was artistically gifted, enjoyed a smooth career, and achieved wide acclaim as one of the major painters of the Lingnan school in the twentieth century.

Yang studied painting in his teens. At twenty-one he showed his works in an exhibition in Guangzhou. The success of this initial venture boosted his self-confidence. He decided to devote the rest of his life to art creation. The young man's talent caught the attention of Gao Jianfu (1879–1951), one of the founders of the Lingnan school. Gao advised him to go abroad to expand his knowledge and scope. In 1935, he travelled to Japan and stayed in Kyoto for three years to study painting at Dōmoto Art Institute under the guidance of Dōmoto Inshō (1891–1975). Upon graduation, he returned home. He began to exhibit his works in Hong Kong and Southeast Asia. In 1940, while exhibiting in Singapore, he met Xu Beihong (1895–1953), a celebrated painter who advocated new approaches to Chinese painting. Xu was greatly impressed by Yang's paintings and gave him much encouragement.

A year later, when Hong Kong came under Japanese occupation, Yang, like many people, sought refuge in nearby Macau. There, he met Gao Jianfu again. Because he lived close to Gao's home, he benefitted from having frequent opportunities to be in Gao's company and to

hear his ideas on artistic matters. He was also active in art circles there. Together with Gao and Feng Kanghou (1901–1983), a renowned calligrapher, he organized the Xieshe, or Society of Harmony, for the promotion of Chinese art. After the end of the Second World War, he and Gao formed another society, the Jinshe huahui (Society of Contemporary Painting), together with Chen Shuren (1884–1948), Li Gemin, Zhao Shao'ang (1903–1998), and Guan Shanyue (1912–2000), all established painters of the Lingnan school.

Yang moved back to Hong Kong in 1948. From then on, he held solo exhibitions in major world cities, including Taipei, Osaka, New York, San Francisco, Honolulu, and Vancouver. In 1970, he established the Chunfeng huahui (Spring Breeze Studio) where he subsequently devoted much time to instructing painting students. In 1988, he emigrated to Canada. Although Vancouver became his new home, he frequently travelled back to Hong Kong, to remain active in art circles.

If Yang Shanshen's successful career was enviably smooth-sailing, it was because he was talented, perceptive, and hard-working. He knew precisely his goals and how best to achieve them. In his early years he followed the traditional method of copying ancient models in painting and calligraphy. This helped him develop a firm foundation for his drawing and writing skills. Over the course of his life he continually sharpened his eyes by

observing everything around him and by painting subjects from life. He also travelled widely to enrich his personal experiences and to broaden his mind. Whenever he was abroad he would visit art galleries and museums, making use of every opportunity to see famous masterpieces. He collected art books on works by world-renowned Western artists, such as Rembrandt and Rodin, so he could study them more carefully. Studying ancient poems was yet another one of his worthy endeavours. The cultural knowledge he acquired not only opened up a wide range of painting subjects for him but also enhanced the intellectual content of his creations. The individualistic style Yang developed was, therefore, the result of a lifelong passionate quest for knowledge and perfection.

This painting depicts four sparrows in a bamboo grove. While the subject may look simple, the work is actually much more interesting than it appears at first glance. In terms of compositional design, the bamboo grove is divided subtly into two groups. The larger group on the right is positioned closer to the viewer, with the smaller group located a little further back. A sense of depth is created through this subtle arrangement. The narrow space that separates them even allows the viewer's gaze to penetrate the distant void.

Elements of contrast and variety also play an important role in enhancing the visual appeal of this work. The lower half of the painting, for example, is dominated by parallel vertical lines that depict the bamboo stems. These lines are punctuated by tiny horizontal lines at irregular intervals that denote the nodes on the stems. Fallen bamboo leaves in the foreground, too, are all arranged horizontally on the ground. They enhance the dispersed tiny horizontal lines to offset the predominant vertical lines. While the interplay between the verticals and horizontals may be subtle, the visual contrast between the orderly bamboo stems depicted in the lower half of the painting and the profuse foliage that takes up the better part of the upper half is quite obvious. The complex relationships between the spiky leaves—rendered with sets of converging diagonal lines—and the stems and twigs from which they issue are illustrated superbly in a way that only a painter who knows his subject well and who has excellent representational skill can accomplish.

Variety is seen not only in the different ways the bamboo leaves turn or overlap. The positions and attitudes of the sparrows as well as the method employed to depict them present a medley of visual delight. In contrast to the *shuanggou* (double outline) lineal painting method used for the bamboo, these birds are represented with colour wash in a spontaneous manner. They are depicted scampering on the ground, perhaps looking for food. Three of them are placed within the larger group of bamboo. One is located with the smaller group at the left. Of particular interest is that among the flock of three birds, one is depicted frontally gazing out at the viewer, two others are depicted exchanging glances with the isolated bird. Their lively expressions certainly add a delightful touch to the whole work.

At the lower left corner Yang Shanshen has written the following poem in his unique handwriting:

[The bamboo's] greenness merges with the [white] clouds
 when a myriad leaves unfurl.
Princes never tire of planting many [stems] in their gardens.
[Although] nobody notices its [ability to] withstand the frost
 that covers it from node to node,
[It still keeps its] hollow heart, awaiting the phoenix to come.[1]
Who will esteem its elegance to add to its versification?

It prides itself for its non-conformity and purity.
Mansions with crimson doors have plenty of unused spaces.
They will be perfect for [the bamboo] to spread its shade over
 the blue-green mosses.
 —A Tang-dynasty poem to fill an empty space,
 inscribed by Yang Shanshen at the Chunfeng caotang
 (Spring Breeze Grass Hut) on the twenty-fifth day
 of the sixth month in the year jiazi (1984).

Yang Shanshen has painted more works of the same subject matter. Two that have been published were created in 1984 and 1987. The 1984 composition is also made up of a bamboo grove that dominates the whole painting proper. But only two sparrows are depicted nestling neck to neck on a branch high up in the upper left corner.[2] The 1987 composition is executed on a horizontal format, with only the bamboo foliage and a pair of sparrows perched on a branch represented as a close-up view.[3] One other published painting depicting a few stems of bamboo using the same technique is dated much earlier, in 1976.[4] These similar works show that even when Yang repeated the same theme, he would approach it from a new perspective each time. It is this quest for innovative changes that sets him apart from many of his contemporary painters.

Notes

1 Farewell Party for Wang Ao

1. This painting has been recorded in a late nineteenth-century painting and calligraphy catalogue. The missing characters in the poems by Wen Lin and Wu Kuan are preserved there. See Tao Liang, *Hongdoushuguan shuhuaji, juan 8*, 16b–17b.

2. Rare because Wu Kuan and Wang Ao lived mostly in the capital around this time and Wen Lin only just returned from his post in Nanjing.

3. The term, *jianghu* (literally, rivers and lakes) is used in the sense of everywhere here.

4. *Taipu* was a title Wen Lin held when he served in the Court of the Imperial Stud in Nanjing. For information about him, see Craig Clunas, *Elegant Debts: The Social Art of Wen Zhengming*, 20–22.

5. For information about Shen Zhou, see L. Carrington Goodrich and Chaoying Fang, eds., *Dictionary of Ming Biography 1368–1644*, vol. 2, 1173–1177.

6. *Fousheng* (literary, a floating life) means a frivolous life.

7. Yingzhou is one of the Three Isles of the Blessed where Daoist immortals are believed to reside. To have reached this paradise implies the attainment of a distinguished and enviable official career. This poetic line refers to Wang Ao, who before 1492 had already served as a senior expositor in the Hanlin Academy, a position entailing the duty of instructing the emperor in his regular classical studies.

8. Wen Lin was the father of Wen Zhengming (1470–1559), Shen Zhou's most outstanding student.

9. The Jin period is well known for the free spirit embraced by some scholars. Particularly famous for their unconventional manners were the members of the so-called Seven Sages of the Bamboo Grove.

10. Shitian is the courtesy name of Shen Zhou. For information about Wu Kuan, see L. Carrington Goodrich and Chaoying Fang, eds., *Dictionary of Ming Biography 1368–1644*, vol. 2, 1487–1489.

11. For information about Wang Ao, ibid., 1343–1347.

12. For reasons supporting Ni Zan's revised dates, see Tan Fuxing, "Guanyu Ni Zan de shengzu shijian—Zhou Nanlao 'Yuan chushi Yunlin xiansheng muzhiming' kaowu."

2 River Landscape

1. Both referred to Yuan by his courtesy name, Bangzheng.

2. This information is given in the biographical sketch included by the anonymous author of *Wochuan yushang bian*, 173.

3. All these artistic and literary creations were later bound together as an album. Ibid., 161–173. At the end of the record are the names of fifteen guests who had been invited to Yuan Biao's studio. Wen Zhengming, Wang Chong, Wen Peng, and Peng Nian were among them.

4. Impressions of seals belonging to the Qianlong emperor and his son the Jiaqing emperor (r. 1796–1850) are found on the painting.

5. The catalogue was commissioned by the Jiaqing emperor (r. 1796–1850) and completed in 1816. For the record of this painting, see Guoli gugong bowuyuan, ed., *Bidian zhulin, Shiqu baoji sanbian*, vol. 2, 971–972.

3 Orchids, Bamboo, and Rocks

1. This painting is mounted together with another painting of orchids and rocks by the same painter. Executed in 1576, the orchids are drawn in a much more spontaneous manner in ink monochrome.

2. See Ma Shouzhen's biography in Tang Souyu, *Yutai huashi, juan* 5, 72.

3. The celebrated event was described in an opera entitled *Bailian qun* (White Silk Skirt) written by Zheng Zhiwen. See Wang Zhideng's biography by Liu Lin-sheng in L. Carrington Goodrich and Chaoying Fang, eds., *Dictionary of Ming Biography*, vol. 2, 1362.

4. For a list of Ma Shouzhen's known works, see Marsha Weidner et al., *Views from Jade Terrace: Chinese Women Artists, 1300–1912*, 183.

5. Verses about Xiang *jun* and Xiang *furen* are included in Qu Yuan's collection of poems entitled *Jiuge* (Nine Songs). There are different interpretations about the identity of these two figures. In one interpretation they were the daughters of the legendary ruler, Yu, who betrothed them to his successor, Shun. Both were heartbroken and died in the Xiang River area after hearing the unexpected death of Shun. In another interpretation they were the goddesses of the Xiang River. For the translation of the two poems about them, see Arthur Waley, *The Nine Songs: A Study of Shamanism in Ancient China*, 29–36. In addition, one of Ma Shouzhen's seals has a legend that reads *jiuwan zhong ren* (a person among nine fields [of orchids]). It provides explicit evidence for her desire to be associated with the ideal of Qu Yuan since it was this poet who professed a wish to cultivate nine fields of orchids so he could immerse himself in their fragrance. An impression of this particular seal is located at the top left at the end of the painting.

6. For discussions of this interpretation, see Li Shi, "Mingdai qinglou wenhua guanzhao xia de nühuajia," 112–113; Xu Wenmei, "Wan Ming qinglou huajia Ma Shouzhen de lanzhuhua."

7. See Marsha Weidner et al., *Views from Jade Terrace: Chinese Women Artists, 1300–1912*, 78–81. Also, for another commentary on the Indianapolis version, see Yutaka Mino and James Robinson, *Beauty and Tranquility: The Eli Lilly Collection of Chinese Art*, 324–325.

8. Zhang Yanchang (1738–1814), Wang Wenzhi (1730–1802), and Xi Gang (1746–1803) were well-known intellectuals skilled in painting and calligraphy.

9. For the only record of Ma Shouzhen's painting in the Zhuangtaoge collection, see Pei Jingfu, *Zhuangtaoge shuhualu, juan* 11, 36a–37b.

4 Flowers, Fruits, and Fish

1. Different dates have been suggested for Chen Zhuan. This is based on the convincing research done by Hu Yi. See Hu Yi, "Chen Zhuan shengzunian kaolue," 79–80.

2. Yang Yuhuan (719–756) is better known as Yang *guifei*, a title she received in 745 after she had become the concubine of Emperor Xuanzong of the Tang dynasty (r. 713–755). Prince Shou was the son of Emperor Xuanzong and the first husband of Yang Yuhuan.

3. Liuru is the style name of Tang Yin (1470–1523), a renowned painter and poet of the Ming dynasty.

4. This reference is about a famous conversation between Zhuangzi (ca. 369–286 B.C.), a Warring States philosopher, and his friend Hui Shi (ca. 370–310 B.C.) concerning Zhuangzi's assertion that leisurely swimming fish are happy.

5. Chen Zhuan's anthologies are entitled *Yuji shanfang yinjuan* and *Xiujia ji*. He has also edited *Yuji shanfang huawai lu*, a book recording commentaries written by various painters.

6. The *boxue hongci* examination was a special examination held at the palace. The participants were all recommended by high officials because of their exceptional literary achievements. Those who passed the examination would be appointed to serve in the Hanlin Academy. Only two such special examinations were held during the Qing dynasty—one in 1679 and the other in 1736.

5 Admiring an Autumn View at Sunset

1. Red dust is a euphemistic term for worldly affairs.

2. The so-called Four Wangs were Wang Shimin (1592–1680), Wang Jian (1598–1677), Wang Hui (1632–1717), and Wang Yuanqi (1642–1715).

3. See Wang Yu, *Dongzhuang lunhua*, 57.

4. This is recorded in *Taicang zhouzhi*, *juan* 22, and quoted in Zheng Wei, "Loudong Wangshi shixi yu huaxi huizhuan," 136.

5. Wang Yu, *Dongzhuang lunhua*, 59.

6. Ibid., 60.

6 Summer Retreat at Lakeside Village

1. Some art historians believe that Yuan Yao was either the brother or the nephew of Yuan Jiang. Their assertions are not convincing enough for serious consideration. See Nie Chongzheng, *Yuan Jiang yu Yuan Yao*, 6.

2. This painting album is now in the collection of the Tianjin Municipal Cultural Bureau. For a discussion about it and an illustration of Yuan Yao's work, see Nie Chongzheng, "Yuan Yao youguan Yangzhou de liangjian zuopin," 46, 48.

3. See Qin Zhongwen, "Qingdai chuqi huihua de fazhan," 56.

4. The information is given in Li Zhizhao's article, "Jiehua de fazhan he jiehua goutu de yanjiu," partially quoted in Nie Chongzheng, *Yuan Jiang yu Yuan Yao*, 3.

5. Since the latest dated work by Yuan Jiang is 1746, it is likely that he died in that year or shortly after and Yuan Yao was summoned by either his ailing father or the Wei family to continue his unfinished work. Ibid.

6. See Qin Zhongwen, "Qingdai chuqi huihua de fazhan," 56.

7. This group of paintings is in the collection of the Palace Museum in Beijing. Two scenes are illustrated in Nie Chongzheng, "Yuan Yao youguan Yangzhou de liangjian zuopin," 47–48.

7 Complete View of the Lion Grove

1. For information supporting his dates and brief notes about Weize, see Zhang Chenghua, *Shizilin*, 108–110.

2. His identity is not recorded.

3. Approximately 6.6 *mou* equal 1 acre. The Taihu rocks are limestone rocks found in the Lake Tai district in the southern part of Jiangsu province. They are characterized by unusual shapes, pitted surfaces, and perforations, made by the natural elements. For many centuries the Chinese have used them to decorate their gardens.

4. The Lion Grove gradually fell into ruins after the fall of the Yuan dynasty. Commoners appropriated the buildings as their living quarters. It was not until the last decade of the sixteenth century that the monastery was restored and its layout redesigned. Later on the garden area again became the property of wealthy families. For details of the history of the Lion Grove up to the present day, see Zhang Chenghua, *Shizilin*, 104–108.

5. This painting no longer exists. See Lin Xingqin, *Zhu Derun yanjiu*, 21, note no. 40. For information about this painter, see James Cahill, *Hills Beyond a River: Chinese Painting of the Yuan Dynasty, 1279–1368*, 79–80.

6. For reasons supporting Ni Zan's revised dates, see Tan Fuxing, "Guanyu Ni Zan de shengzu shijian—Zhou Nanlao 'Yuan chushi Yunlin xiansheng muzhiming' kaowu." For Zhao Yuan's dates, see Hu Mulan, "Mingdai Suzhou diqu shanshuihua de 'qianjing,'" 38, note no. 4. For information about Ni Zan and Zhao Yuan, see James Cahill, *Hills Beyond a River: Chinese Painting of the Yuan Dynasty, 1279–1368*, 114–120, 129–130. This work is now in the collection of the Palace Museum in Beijing. For partial illustrations, see Osvald Sirén, *Chinese Painting: Leading Masters and Principles*, vol. 6, pl. 102.

7. They include Xu Ben, Du Jin (1396–1474), Wen Zhengming (1470–1559), Wen Boren (1502–1575?), Lan Ying (b. 1585), Zheng Min (1607–after 1682) of the Ming dynasty and Zha Shibiao (1615–1698), Fang Zong (act. 18th century), Qian Weicheng, Liu Yin (act. 19th century), Li Jiafu (1829–after 1895), Gu Linshi (1865–1930) and Fan Haolin (b. 1880) of the Qing dynasty. For reference to Xu Ben, see John C. Ferguson, *Lidai zhulu huamu*, vol. 2, 230a; for Wen Boren and Wen

Zhengming, ibid., vol. 1, 16a and 20b; for Zheng Min and Lan Ying, vol. 4, 418b and 453b; for an illustration and brief discussion of Du Jin's work, see Hu Mulan, "Mingdai Suzhou diqu shanshuihua de 'qianjing,'" 28; for Zha Shibiao, see Tong Jun, *Jiangnan yuanlin zhi*, 29; for an illustration of Fang Zong's work, see Gugong bowuyuan, ed., *Qingdai gongting huihua*, 179, pl. 101; for Liu Yin, see *Fine Chinese Paintings from the Currier Collection* (Sotheby's, Hong Kong, 1 May 2000), lot no. 104; for Li Jiafu, see *Fine Chinese Paintings* (Sotheby's, Hong Kong, 7 April 2006), lot no. 309; for Gu Linshi, see Guoli lishi bowuguan bianji weiyuanhui, ed., *Wan Qing Minchu shuimohua ji*, 183, pl. 59; for Fan Haolin, see *Fine Chinese Paintings* (Sotheby's, New York, 31 May 1989), lot no. 154.

8. The Qianlong emperor conducted altogether six southern inspection tours. He started to visit the Lion Grove on his second tour.

9. For example, Fang Zong, a court painter, was ordered to do the same. See John C. Ferguson, *Lidai zhulu huamu*, vol. 1, 31a. Dong Gao (1740–1818), a high official proficient in painting, painted the Lion Grove in Wen yuan (Garden of Refinement) at the Qianlong emperor's behest. Ibid., vol. 3, 368b.

10. For his biographical sketch, see Arthur W. Hummel, ed., *Eminent Chinese of the Ch'ing Period*, vol. 1, 158. A total of 160 works by Qian Weicheng are recorded in the imperial painting catalogue, *Shiqu baoji*. This staggering number is a good indication of how highly respected he was by the Qianlong emperor. See Nie Chongzheng, "Wo kan Qian Weicheng lin Dong Qichang jiurutu zhou," 55.

11. See Zhang Geng, *Guochao hua zheng xulu*, part 2, 103; Qin Zuyong, *Tongyin lunhua*, juan 6, 146. For a biographical sketch of Dong Bangda, see Arthur W. Hummel, ed., *Eminent Chinese of the Ch'ing Period*, vol. 2, 792.

12. For information about them, see James Cahill, *Hills Beyond a River: Chinese Painting of the Yuan Dynasty, 1279–1368*, 68–74, 85–127.

13. For a biographical sketch of Wang Yuanqi, see Arthur W. Hummel, ed., *Eminent Chinese of the Ch'ing Period*, vol. 2, 844–845.

8 Drawings of Costume and Accessories of the Empress Dowager and Empress

1. As soon as he ascended the throne in 1736, the Qianlong emperor ordered the compilation of the *Da Qing huidian* (Regulations of the Great Qing). He also immediately increased the number of members of the imperial clan to be in attendance at the annual sacrificial ceremony. In the following year, he gave an order that all district governors must conduct sacrificial rites with their staff in spring and autumn. In 1742, he instructed that the state ritual of praying to heaven for rain be held at the Qinian dian (Hall of Prayer for a Good Year), located north of the Tiantan (Altar of Heaven) in the southern outskirts of Beijing.

2. For the biographies of Prince Zhuang and Jiang Pu, see Arthur W. Hummel, ed., *Eminent Chinese of the Ch'ing Period*, vol. II, 925–926 and vol. I, 143. For those of Wang Youdun, Sanhe, and He Guozong, see *Qingshi gao*, juan 302, 10456–10458; juan 291, 10285; and juan 283, 10184–10186, respectively.

3. This information is given in the list of major project participants attached to Prince Zhuang's report. See Yunlu et al., *Huangchao liqi tushi*, 6. Only Men Yingzhao is recorded. See Hu Jing, *Guochao yuanhua lu*, 62 and Yu Jianhua, ed., *Zhongguo meishujia renming cidian*, 565.

4. This number is given in Liu Lu, "Yibu guifan Qingdai shehui chengyuan xingwei de tupu: youguan 'Huangchao liqi tushi' de jige wenti," 130. Ming Wilson, however, says that, "There are a total of 1,384 illustrations in the printed version, but the manuscript version definitely would have more." See her "New Research on the Ceremonial Paraphernalia Album in the V&A," 52.

5. For Fulong'an's biography, see Arthur W. Hummel, ed., *Eminent Chinese of the Ch'ing Period*, vol. 1, 259–260.

6. Ming Wilson believes that both the manuscript version and the printed version were completed in 1759, using as evidence a report from Prince Zhuang, which Wilson translates as follows: "25th year of Qianlong [1760]…[we have] produced one set of colour illustrations and delivered to the Nanxun

Palace, two sets of ink illustrations and delivered to the Wuying Palace, one to be made into a book, one for cutting blocks. When printing is complete they will be presented to the throne for approval." See Ming Wilson, "New Research on the Ceremonial Paraphernalia Album in the V&A," 57. The two sets of ink illustrations were likely line drawings executed by hand, not by printing, since the last sentence clearly indicates that printing had yet to be done.

7. In addition to the five Boards mentioned above, the sixth was the Board of Punishment.

8. Two folios made of gold-flecked paper bear the seal impressions of *Yuanming yuan bao* (Treasure of the Garden of Perfect Brightness) and *Wufuwudaitang guxi tianzi bao* (Treasure of the august emperor's Hall of Five Happinesses in Five Generations). The latter belongs to a seal used by the Qianlong emperor. Another seal legend, *Qianlong yulan zhi bao* (Treasure seen by the Qianlong emperor) can also be seen on a folio depicting a winter court headdress.

9. The exact number of drawings in the collection of the Palace Museum in Beijing is unknown. Liu Lu, a curator of that museum, did not disclose this information in a paper she read in a conference held in 2003. Nor did she mention it in her article published a year later. Besides the Mactaggart Art Collection that now belongs to the University of Alberta, other public institutions that own drawings from this original set include the Victoria and Albert Museum, National Museum of Scotland, Dublin Museum of Art and Science, and British Library. The V&A is the major repository. Margaret Medley was the first person to research its large collection, built up over a period of time. For the results of her research, see *The 'Illustrated Regulations for Ceremonial Paraphernalia of the Ch'ing Dynasty.'* A number of drawings of costumes and accessories from the collections of the V&A and the British Library are illustrated in Gary Dickinson and Linda Wrigglesworth, *Imperial Wardrobe*. Of interest is that the National Museum (previously known as the History Museum) in Beijing also owns a collection of coloured drawings of similar objects in reduced size (each leaf 28.6 x 30.9 cm). This group, consisting of about 2,000 leaves bound in 92 volumes, was formerly kept in the summer palace in Chengde. See Ming Wilson, "New Research on the Ceremonial Paraphernalia Album in the V&A," 58–59.

10. Sir Thomas Phillipps has been described as "the greatest collector of books and manuscripts that the world has ever known." He purchased this group of drawings at the Puttick and Simpson Sale in 1863 in London. Philip Robinson, another avid bibliophile, acquired a vast residue of the Phillipps Collection in 1946, among which were these drawings. See *The Library of Philip Robinson, Part II, The Chinese Collection*, Preface.

11. According to the description given in the sales catalogue, these drawings belong to volume 13 out of 20 volumes that make up the costume section in the original set. See ibid., 35.

12. Men Yingzhao's name is also included in another list of participants attached to Fulong'an's report. See Yunlu et al., *Huangchao liqi tushi*. Reprint, 10.

9 The Qianlong Emperor's Southern Inspection Tour No. 2

1. The content of this scroll is identified by an inscription composed by the Qianlong emporer and brushed by Yu Minzhong (1714–1780) on its upper right corner.

2. The Kangxi emperor's six tours took place in 1684, 1689, 1699, 1703, 1705, and 1707. For detailed information, see Maxwell Kessler Hearn, *The "Kangxi Southern Inspection Tour": A Narrative Program by Wang Hui*. The Qianlong emperor undertook similar tours in 1751, 1757, 1762, 1765, 1780, and 1784. For a study of these tours, see Michael G. Chang, *A Court on Horseback: Constructing Manchu Ethno-dynastic Rule in China, 1751–1784*.

3. This set was designed by Wang Hui (1632–1717). It was completed with the assistance of Yang Jin (1644–1728) and other unnamed court painters.

4. At present, the whereabouts of only five other scrolls in the set commissioned by the Qianlong emperor is known: no. 3 is in the collection of the Musée des Beaux-Arts Jules-Chéret in

Nice; no. 4 is in the Metropolitan Museum of Art in New York; no. 10 is in the Musée Guimet in Paris; nos. 9 and 12 are in the Palace Museum in Beijing.

5. In the Qianlong emperor's biography, the empress dowager was mentioned as a participant of this tour. See Zhao Erxun et al., *Qingshi gao*, *juan* 11, 410. The presence of the senior officials was necessary so that the emperor could still have their advice while attending to state affairs on the journey.

6. This set, which is intact, is now in the collection of the National Museum in Beijing.

7. See Jin Hou, "Xu Yang he tade nanxun jidaotu juan," 15.

8. Before Xu Yang became a court painter, he obtained the lowest literary degree, a *jiansheng* (Student of the Imperial Academy). After arriving at the court, he continued to study in order to gain higher degrees. The Qianlong emperor obliged him with two opportunities to sit for the civil-service examination, but he failed both times. Ibid.

10 Conquest of the Western Frontier of China

1. For details of these conquests, see Ka Bo Tsang, "Portraits of Meritorious Officials: Eight Examples from the First Set Commissioned by the Qianlong Emperor," 69–70.

2. The stelae were installed in Ili, Gädän-Ola, Yarkand, and Yesil-Kol-Nor respectively.

3. For details of the commission of this set of engravings in Paris, see Michèle Pirazzoli-T'serstevens, *Gravures des conquêtes de l'empereur de chine k'ien-long au musée guimet*, 10–20.

4. See Zhuang Jifa, "Desheng tu: Qingdai de tongbanhua," 108. In Europe the French engraver Isidore-Stanislas Helman (1743–1806), a student of Le Bas, reproduced this set in half of its original size between 1783 and 1785. He also added four more illustrations of a Chinese emperor conducting an official ceremony of spring ploughing and being escorted by processions on his excursions. He entitled this group of 20 engravings *Batailles et conquêtes de l'empereur de la Chine*. See Weng Lianqi, "Qingdai neifu tongbanhua kanke shulue," 44. For

illustrations, see *The Andrew Franklin Collection of Asian Art*, lot 106, 35–38.

5. Biographical sketches of most of these officials can be found in Arthur W. Hummel, ed., *Eminent Chinese of the Ch'ing Period*. For Fuheng, vol. 1, pp. 252–253; Liu Tongxun, vol. 1, 533–536; Shuhede, vol. 2, 659–661; Yin Jishan, vol. 2, 920–921; Yu Minzhong, vol. 2, 942–944. For Aligun, see *Qingshi gao*, vol. 35, *juan* 313, 10675–10679.

6. For his biography, see *Qingshi gao*, vol. 36, *juan* 332, 10967–10968.

7. These included the pacification of Jichuan, Taiwan, Annam, Nepal, the Miao, and the Uighur.

8. The order of the engravings given here has been checked against the illustrations in two publications, Michèle Pirazzoli-T'serstevens, *Gravures des conquêtes de l'empereur de chine k'ien-long au musée guimet* and Giuseppe Castiglione et al., *Qingdai yuzhi tongbanhua*, with minor adjustments. The engravings illustrated in the latter follow the hand-painted version closely. Both have the Qianlong emperor's poems inscribed at the top of the depicted scenes, with no additional annotations. Both are in the collection of the Palace Museum in Beijing.

11 Flowers, Birds, Fish, and Rabbit

1. Tianchisheng is the style name of Xu Wei (1521–1593), a painter well known for his spontaneous brush and inkwork.

2. Luo Ping's other names include Dunfu, Huazhisi seng, Jinjiu shanren, Luzhou yufu, Yiyun daoren, and Zhusou. His most frequently used name, Liangfeng, was coined in commemoration of his ancestral native place, the Chengkan village in Shexian. Located at the foot of the Yellow Mountain, villagers could see the famous Lotus Peak and Heavenly Capital Peak clearly when they gazed upward.

3. Two landscapes by Luo Zhi are in the collection of the Yangzhou Museum. See Zhang Yuming, "Luo Ping he tade yishu daolu," 8.

4. Ibid., 14.

5. Luo Ping's trips to the north were taken from 1771 to 1774, 1779 to 1780, and 1790 to 1798. Researchers have offered various speculations about Luo's reasons for leaving home, among which are: following Jin Nong's advice, he wanted to broaden his knowledge and outlook; to establish new contacts to facilitate the sale of his paintings, which had considerably declined after a serious corruption case was brought against the major salt merchants who were the leading patrons of the arts in Yangzhou; and most important of all, to act as an intermediary for the salt merchants to ease the situation. For details, ibid., 15–16.

6. The *Guiqu tu* (The Destiny of Yakas, Raksasas, and Hungry Ghosts), for example, which he painted around 1766, caused quite a stir in the art circles in Beijing when he first visited the capital.

7. Jin Nong's paintings are characterized by his indifference to polished painting techniques and realistic images. He instilled into his brush manner a directness and angularity typical of some of the scripts engraved on bronze vessels and stone stelae—creating a strong feeling of naïveté, which to him meant the true spirit of antiquity.

8. It is intriguing that the rabbit's left hind paw is missing. One can only speculate its reason.

12 Drawings of Chinese Figures

1. William Alexander's views of China were published in 1805 by William Miller under the title of *The Costume of China*. They were reprinted in 1988 together with some of the plates from another book of a similar title published by Miller in 1804. The works illustrated in both books show the typical Europeanized Chinese faces with deep-set large eyes and high noses. See William Alexander and George Henry Mason, *Views of 18th Century China: Costumes, History, Customs*.

2. Mason was serving as Lieutenant in the 36th Regiment and Major of Brigade in the British forces on the coast of Coromandel.

3. See the Preface in George Henry Mason, *The Costume of China*.

4. *The Punishments of China* was published in 1801. *The Costume of China* was published in 1804. The source of the original drawings on which the engraved plates in *The Punishments of China* are based is not identified. Mason's name was not referenced on the book's title page. It is likely that the same information is true of both books since they were published by William Miller and there is strong stylistic affinity between the illustrations in both books.

5. For information about the lives and works of both artists, see Martin Hardie and Muriel Clayton, "Thomas Daniell, R.A. (1749–1840), William Daniell, R.A. (1769–1837)."

6. Among the fifty colour aquatints were views of places (Macao, Canton, Hotun on the Canton River, Whampoa), architecture (pavilion, fort, pagoda, garden), boats (duck boats, junks, trading and fishing vessels), and people (civil official, military officer, mandarin, barber, farmer). These examples are in the collection of the National Maritime Museum in Britain.

7. Compare no. 109 in this album with pl. 4 in *The Punishments of China*; no. 110 with pl. 7; no. 111 with pl. 9; no. 112 with pl. 22; no. 113 with pl. 15; and no. 114 with pl. 13.

8. See *The Costume of China*, pls. 2 and 31.

13 Drawings of Flowers and Insects

1. The first name is inscribed together with a note on a blank page at the beginning of the album. The handwriting is not easy to decipher. For information about Phillipps and his enormous library, see A.N.L. Munby, *Phillipps Studies*, nos. 1–5. For Robinson, see *The Library of Philip Robinson, Part II, The Chinese Collection*, "The Robinson Chinese Collection" and the Preface.

2. These studies are reminiscent of traditional paintings of insects. The earliest extant example is Huang Quan's (903–965) handscroll of birds and insects. Painted in a similar casual layout, it was probably intended to be used as a model for his son, Huang Jucai, to learn from. Part of it is illustrated in Roderick Whitfield, *Fascination of Nature: Plants and Insects in Chinese Painting and Ceramics of the Yuan Dynasty (1279–1368)*, 8. A more recent example is Zhu Rulin's handscroll of 1711

depicting a large number of insects against a neutral background. For illustration and explanation, see Liu Fangru, "Zhongguo guhua li de caocong shijie," 110–113.

3. Many examples are illustrated in Paul Hulton and Lawrence Smith, *Flowers in Art from East and West*, some showing details of certain parts of a plant as well.

4. A small number of people are recorded to have collected and sent plant seeds or specimens home while they were abroad. Joseph Camel (1661–1706), for example, collected plants from the Chinese community in Manila and sent dried specimens back to Europe while he served as a Moravian Jesuit missionary in the Philippines. James Cunningham (d. 1709?), a Scottish East India Company surgeon, was the first Western botanist to collect plants within China when he was stationed in Amoy. See Karina H. Corrigan, "Chinese Botanical Paintings for the Export Market," 92–93.

5. For a discussion of all three kinds of paper, see Craig Clunas, *Chinese Export Watercolours*, 45, 77, and 80. The three kinds of botanical watercolours are all illustrated in the same book, 75, 76, 85, and 87.

6. Copying and painting went hand in hand in Chinese commercial painting studios. One satisfied customer made this remark in 1804, "The coloured prints of Europe that are carried out to Canton are copied there with wonderful fidelity." (Quoted in Craig Clunas, *Chinese Export Watercolours*, 76.) Also see page 38 for a picture of a Chinese painter copying a European print onto glass.

14 Luohan

1. "Eight-legged essays" were essays written in a set format dictated by the civil-service examination system.

2. Five reasons, including the three mentioned here, are offered in Pierre Ryckmans, *The Life and Work of Su Renshan*, 23–29.

3. See Kao Mayching, ed., *Su Liupeng Su Renshan shuhua*, 128.

4. This painting is recorded in Jian Youwen, *Huatan guaijie Su Renshan*, 21, fig. 61. It is also illustrated in Claudia Brown and

Ju-hsi Chou. *Transcending Turmoil: Painting at the Close of China's Empire 1796–1911*, 295, no. 101.

5. Yangming's real name was Wang Shouren (1472–1528). He was a high official and a well-known philosopher. For his biography, see L. Carrington Goodrich and Chaoying Fang, eds., *Dictionary of Ming Biography 1368–1644*, vol. 2, 1408–1416.

6. Baisha's real name was Chen Xianzhang (1428–1500). He was a renowned philosopher, educator, and calligrapher. For his biography, ibid., vol. 1, 153–156.

7. The Guang sect may refer to the Vinaya school of Buddhism, founded by Monk Daoxuan of the Tang dynasty, which emphasizes the monastic discipline. The Zhe school may refer to the Yongkang school, a branch of Confucianism which flourished during the Song dynasty. It was also called the Zhe school because it was based in Zhejiang province.

8. The "four greatnesses" is a literal translation of the Chinese term *sida*. In Buddhist parlance this term refers to the four elements of which all things are made, i.e., earth, water, fire, and wind. Chinese Buddhists also use this term to mean a human being since humans are also made up of these elements. See Cihai bianjiweiyuanhui, ed., *Cihai*, vol. 2, 1732.

9. For *luohans* depicted in groups, see Pierre Ryckmans, *The Life and Work of Su Renshan*, 127, fig. 35; and Kao Mayching, ed., *Su Liupeng Su Renshan shuhua*, 282, no. 2.53. For depictions of a single *luohan*, see Kao, 286–287, no. 2.54A (7, 8).

10. Ibid., 199–200, no. 2.11.

15 Battle Scene from the Nian Rebellion

1. For biographical information on Hong Xiuquan, see Arthur W. Hummel, ed., *Eminent Chinese of the Ch'ing Period*, vol. 1, 361–364.

2. For the biographies of Zeng Guofan and Li Hongzhang, see ibid., vol. 2, 751–755 and vol. 1, 464–471.

3. The set depicting the Qing forces' pacification of the Taiping Rebellion consisted of 20 paintings. Another set featuring battle scenes in connection with the quelling of the Nian Rebellion had 18 paintings. Both sets were executed by court painters. Each set exists in two versions: as preliminary line

drawings and as finished products. The preliminary drawings are in the collection of The First Historical Archives of China in Beijing. The paintings based on the preliminary drawings are in the Palace Museum, Beijing. Illustrations of some of the examples from these two sets can be found in Zhu Chengru, ed., *Qingshi tudian*, vol. 10, *Xianfeng Tongzhi chao*, 21–62. There is yet one more set which depicts the quelling of the Miao and the Muslim insurrections (1850–1872, 1855–1874) in south-west and northwest China, also in the collection of the Palace Museum, Beijing. For illustrations, see ibid., 71–80. Since the painting style is consistent throughout the three sets of paint-ings, it is likely that they were all executed by the same group of court painters during the latter half of the 1870s, after the conquest of the Muslim Rebellion was accomplished. If this assumption proves to be correct, the Qing government would have been under the rule of the Guangxu emperor (r. 1875–1908).

4. In 1855, Zhang Luoxing called a meeting of Nian leaders from different places. He himself was elected to be the chief commander. Among the many policies he instigated was the organization of an armed force under a five-banner system. The colours of the five banners were yellow, red, blue, white, and black. In this painting, although a white banner is missing, the presence of banners in all other four colours is enough to suggest this association.

5. For an illustration of this painting, see Zhu Chengru, ed., *Qingshi tudian*, vol. 10, *Xianfeng Tongzhi chao*, 62.

6. This is a tentative suggestion. More research is needed for confirmation. Also, the original number of this painting within the set has yet to be established.

16 Cliff Landscape

1. For Shi Lu's biography, see Shi Guo, "Shi Lu nianbiao," 40–44; Lou Deming, "Shi Lu nianpu," 118–127; Chan Chuanxi, *Huatan dianjiang lu: ping xiandai mingjia yu dajia*, 155.

2. For an illustration of *Turning to Northern Shaanxi to Fight*, see Mayching Kao, ed., *Twentieth-Century Chinese Painting*, p. xxx, pl. 20; for *On the way to Nanni Bay*, see *Mingjia hanmo* 47, 60.

3. For illustrations of some of the works Shi Lu executed from 1952 to 1972, see Robert Hartfield Ellsworth, *Later Chinese Painting and Calligraphy 1800–1950*, vol. 2, 286–293.

4. Longmen is located to the northwest of Hejin district in Shanxi province and to the northeast of Hancheng district in Shaanxi province.

5. Robert Hartfield Ellsworth observes that Shi Lu stopped using engraved seals in the 1960s. Instead he similated seal impres-sions by painting them. See Robert Hartfield Ellsworth, *Later Chinese Painting and Calligraphy 1800–1950*, vol. 1, 31.

6. For illustrations, see *Mingjia hanmo* 47, 63, 73. Yu Pass is another name of Longmen, so called to commemorate Yu, a legendary hero, who has been credited for opening up this pass 4,200 years ago as part of his flood-control programs.

17 Sparrows in a Bamboo Grove

1. According to legend, the phoenix (*fenghuang*) only stayed on the branch of the paulownia, ate the bamboo shoots, and drank sweet spring water. It appeared only during times of peace when the country was governed by an able ruler.

2. See Li Zhujin and Wan Qingli, *Zhongguo xiandai huihuashi, dangdai zhi bu, 1950–2000*, 98, pl. 5.52.

3. Hong Kong Museum of Art, *Tradition and Innovation: Twentieth Century Chinese Painting*, 280–281, no. 89.

4. Hong Kong Museum of Art, *The Art of Yang Shen-sum*, 32, no. 23.

Bibliography

Alexander, William and George Henry Mason. *Views of 18th Century China: Costumes, History, Customs*. London: Studio Editions, 1988.

The Andrew Franklin Collection of Asian Art. Christie's South Kensington (May 10, 2006).

Brown, Claudia and Ju-hsi Chou. *Transcending Turmoil: Painting at the Close of China's Empire 1796–1911*. Phoenix: Phoenix Art Museum, 1992.

Cahill, James. *Hills Beyond a River: Chinese Painting of the Yuan Dynasty, 1279–1368*. New York: Weatherhill, 1976.

Castiglione, Giuseppe, et al. *Qingdai yuzhi tongbanhua*. Beijing: Guoji wenhua chuban gongsi, 1999.

Chang, Michael G. *A Court on Horseback: Constructing Manchu Ethno-dynastic Rule in China, 1751–1784*. Ph.D. dissertation. San Diego: University of California, San Diego, 2001.

Chen, Chuanxi. *Huatan dianjiang lu: ping xiandai mingjia yu dajia*. Reprint. Beijing: Sanlian shudian, 2006.

Cihai bianjiweiyuanhui, ed. *Cihai*. 3 vols. Shanghai: Shanghai cishu chubanshe, 1979.

Clunas, Craig. *Chinese Export Watercolours*. Essex: Victoria and Albert Museum, 1984.

———. *Elegant Debts: The Social Art of Wen Zhengming*. Honolulu: University of Hawaii Press, 2004.

Contag, Victoria and Wang Chi-ch'ien. *Seals of Chinese Painters and Collectors of the Ming and Ch'ing Periods*. Hong Kong: Hong Kong University Press, 1966.

Corrigan, Karina H. "Chinese Botanical Paintings for the Export Market," *Antiques* 165, no. 6 (2004): 92–101.

Dickinson, Gary and Linda Wrigglesworth. *Imperial Wardrobe*. Revised edition. Berkeley and Toronto: Ten Speed Press, 2000.

Ellsworth, Robert Hatfield. *Later Chinese Painting and Calligraphy 1800–1950*. 3 vols. New York: Random House, 1987.

Ferguson, John C. *Lidai zhulu huamu*. Nanjing: Jinling daxue, 1934.

Fine Chinese Paintings. Sales catalogue; sale of 31 May 1989. New York: Sotheby's, 1989.

Fine Chinese Paintings. Sales catalogue; sale of 7 April 2006. Hong Kong: Sotheby's, 2006.

Fine Chinese Paintings from the Currier Collection. Sales catalogue; sale of 1 May 2000. Hong Kong: Sotheby's, 2000.

Goodrich, L. Carrington and Chaoying Fang, eds. *Dictionary of Ming Biography 1368–1644*. 2 vols. New York and London: Columbia University Press, 1976.

Gugong bowuyuan, ed. *Qingdai gongting huihua*. Beijing: Wenwu chubanshe, 1995.

Guoli gugong bowuyuan, ed. *Bidian zhulin, Shiqu baoji sanbian*. Taipei: Guoli gugong bowuyuan, [1969].

Guoli lishi bowuguan bianji weiyuanhui, ed. *Wan Qing Minchu shui-mohua ji*. Taipei: Guoli lishi bowuguan, 1997.

Hardie, Martin and Muriel Clayton. "Thomas Daniell, R.A. (1749–1840), William Daniell, R.A. (1769–1837)." *Walker's Quarterly*, nos. 35–36 [combined issue]. London: Walker's Galleries, 1932.

Hearn, Maxwell Kessler. *The "Kangxi Southern Inspection Tour": A Narrative Program by Wang Hui*. Ph.D. dissertation. Princeton: Princeton University, 1990.

Hong Kong Museum of Art. *The Art of Yang Shen-sum*. Hong Kong:
the Urban Council, 1981.

Hong Kong Museum of Art. *Tradition and Innovation: Twentieth Century
Chinese Painting*. Hong Kong: the Urban Council, 1995.

Hu, Jing. *Guochao yuanhua lu*. Reprint. In Yu Anlan, ed. *Huashi
congshu*, vol. 8. Shanghai: Shanghai renmin meishu
chubanshe, 1963.

Hu, Mulan. "Mingdai Suzhou diqu shanshuihua de 'qianjing,'"
Lishi wenwu 112, no. 11 (2002): 24–39.

Hu, Yi. "Chen Zhuan shengzunian kaolue," *Duoyun* 30, no. 3 (1991):
79–80.

Hulton, Paul and Lawrence Smith. *Flowers in Art from East and West*.
London: British Museum Publications, 1979.

Hummel, Arthur W., ed. *Eminent Chinese of the Ch'ing Period*. 2 vols.
Washington, D.C.: United States Government Printing
Office, 1944.

Jian, Youwen. *Huatan guaijie Su Renshan*. Hong Kong: Jianshi
Mengjin shuwu, 1970.

Jin, Hou. "Xu Yang he tade nanxun jidaotu juan," *Shoucangjia* 97,
no. 11 (2004): 15–17.

Kao, Mayching, ed. *Twentieth-Century Chinese Painting*. Hong Kong:
Oxford University Press, 1988.

———. *Su Liupeng Su Renshan shuhua*. Hong Kong: The Art Gallery,
The University of Hong Kong and Guangzhou Art Gallery,
1990.

Li, Shi. "Mingdai qinglou wenhua guanzhao xia de nühuajia,"
Gugong wenwu yuekan 17, no. 12 (2000): 108–116.

Li, Zhujin and Wan Qingli. *Zhongguo xiandai huihuashi, dangdai zhi
bu, 1950–2000*. Taipei: Shitou chuban gufen youxian gongsi,
2003.

The Library of Philip Robinson: Part II, The Chinese Collection. Sales cata-
logue; sale of 22 November 1988. London: Sotheby's, 1988.

Lin, Xingqin. *Zhu Derun yanjiu*. MA thesis. Taipei: Guoli Taiwan
daxue, 1975.

Liu, Fangru, "Zhongguo guhua li de caocong shijie," *Gugong wenwu
yuekan* 19, no. 5 (2001): 92–115.

Liu, Lu. "Yibu guifan Qingdai shehui chengyuan xingwei de tupu:
youguan 'Huangchao liqi tushi' de jige wenti," *Gugong
bowuyuan yuankan* 114, no. 4 (2004): 130–144.

Liu, Xiaochun. "Shi Lu yishu de sanbu," *Mingjia hanmo* 47
(December 1993): 14–24.

Lou, Deming. "Shi Lu nianpu," *Duoyun* 39, no. 4 (1993): 118–127.

Mason, George Henry. *The Punishments of China*. London: William
Bulmer and Co., 1801.

———. *The Costume of China*. London: William Bulmer and Co.,
1804.

Medley, Margaret. *The 'Illustrated Regulations for Ceremonial
Paraphernalia of the Ch'ing Dynasty.'* Reprint. London: Han-Shan
Tang, 1982.

Mingjia hanmo 47 (December 1993).

Munby, A.N.L. *Phillipps Studies*, nos. 1–5. Cambridge: Cambridge
University Press, 1951–1960.

Nie, Chongzheng. "Yuan Yao youguan Yangzhou de liangjian
zuopin," *Wenwu* 275, no. 4 (1979): 40–48.

———. *Yuan Jiang yu Yuan Yao*. Shanghai: Shanghai renmin meishu
chubanshe, 1982.

———. "Wo kan Qian Weicheng lin Dong Qichang jiurutu zhou,"
Shoucangjia 104, no. 6 (2005): 55–56.

Pei, Jingfu. *Zhuangtaoge shuhualu*. Reprint. Taipei: Zhonghua shuju,
1971.

Pirazzoli-T'serstevens, Michèle. *Gravures des conquêtes de l'empereur de
chine k'ien-long au musée guimet*. Paris: Musée Guimet, 1969.

Qin, Zhongwen. "Qingdai chuqi huihua de fazhan," *Wenwu cankao
ziliao* 96, no. 8 (1958): 53–58.

Qin, Zuyong, *Tongyin lunhua*. Reprint. In Yang Jialuo, ed. *Hualun
congkan xuji*. Taipei: Dingwen shuju, 1975.

Ryckmans, Pierre. *The Life and Work of Su Renshan*. Translated by
Angharad Pimpaneau. Paris and Hong Kong: University of
Paris, 1970.

Shangguan, Zhou. *Wanxiaotang huazhuan*. Reprint. Beijing:
Zhongguo shudian, 1984.

Shi, Guo. "Shi Lu nianbiao," *Mingjia hanmo* 47 (December 1993):
40–44.

Sirén, Osvald. *Chinese Painting: Leading Masters and Principles*. vol. 6. London: Lund Humphries, 1958.

Tan, Fuxing. "Guanyu Ni Zan de shengzu shijian—Zhou Nanlao 'Yuan chushi Yunlin xiansheng muzhiming' kaowu," *Duoyun* 34, no. 3 (1992): 26–29.

Tang, Souyu. *Yutai huashi*. In Yu Anlan, ed. *Huashi congshu*, vol. 8. Shanghai: Shanghai renmin meishu chubanshe, 1963.

Tao, Liang. *Hongdoushuguan shuhuaji*. Wuqu: Pan Weiyuan, 1882.

Tong, Jun. *Jiangnan yuanlin zhi*. Nanjing: Zhongguo gongye chubanshe, 1962.

Tsang, Ka Bo. "Portraits of Meritorious Officials: Eight Examples from the First Set Commissioned by the Qianlong Emperor," *Arts Asiatiques* 47 (1992): 54, 69–88.

Waley, Arthur. *The Nine Songs: A Study of Shamanism in Ancient China*. London: George Allen and Unwin, 1956.

Wang, Yu. *Dongzhuang lunhua*. In Yang Jialuo, ed. *Yishu congbian*, vol. 14 [group 5]:57–64. Taipei: Shijie shuju, 1962.

Weidner, Marsha, et al. *Views from Jade Terrace: Chinese Women Artists, 1300–1912*. New York: Rizzoli; Indianapolis: Indianapolis Museum of Art, 1988.

Weng, Lianqi. "Qingdai neifu tongbanhua kanke shulue," *Gugong bowuyuan yuankan* 96, no. 4 (2001): 41–50.

Whitfield, Roderick. *Fascination of Nature: Plants and Insects in Chinese Painting and Ceramics of the Yuan Dynasty (1279–1368)*. Seoul: Yekyong Publications, 1993.

Wilson, Ming. "New Research on the Ceremonial Paraphernalia Album in the V&A," *Transactions of the Oriental Ceramic Society* 68 (2003–2004): 51–59.

Wochuan yushang bian. In Huang Binhong and Deng shi, eds. *Meishu congshu*, vol. 11, [group 3, part 2]:113–241. Taipei: Yiwen yinshuguan, [1975].

Xu, Wenmei. "Wan Ming Qinglou huajia Ma Shouzhen de lanzhuhua," *Gugong xueshu jikan* 21, no. 3 (2004): 81–115.

Yu, Jianhua, ed. *Zhongguo meishujia renming cidian*. Shanghai: Shanghai renmin meishu chubanshe, 1981.

Yunlu, et al. *Huangchao liqi tushi*. Reprint. Yangzhou: Guangling shushe, 2004.

Yutaka, Mino and James Robinson. *Beauty and Tranquility: The Eli Lilly Collection of Chinese Art*. Indianapolis: Indianapolis Museum of Art, 1983.

Zhang, Chenghua. *Shizilin*. Suzhou: Guwuxuan chubanshe, 1998.

Zhang, Geng. *Guochao hua zheng xulu*. Reprint. In Yu Anlan, ed. *Huashi congshu*, vol. 5. Shanghai: Shanghai renmin meishu chubanshe, 1963.

Zhang, Yuming. "Luo Ping he tade yishu daolu," in Xing Lihong, ed. *Yangzhou huapai shuhua quanji: Luo Ping*. Tianjin: Tianjin renmin meishu chubanshe, 1999.

Zhao, Erxun, et al. *Qingshi gao*. Beijing: Zhonghua shuju, 1977.

Zheng, Wei. "Loudong Wangshi shixi yu huaxi huizhuan," *Duoyun* 39, no. 4 (1993): 128–144.

Zhu, Chengru, ed. *Qingshi tudian*, vol. 10, *Xianfeng Tongzhi chao*. Beijing: Zijincheng chubanshe, 2002.

Zhuang, Jifa. "Desheng tu: Qingdai de tongbanhua," *Gugong wenwu yuekan* 15, no. 6 (1984): 102–109.